THEN *&* NOW

TOPSAIL ISLAND

Property of:

816 VILLAS DRIVE

OPPOSITE: Fishing is, and always has been, a popular pastime and a way of life for many people then and now. Three oceanfront fishing piers are still on the island: the Surf City Pier, the Sea View Pier in North Topsail Beach, and the Jolly Roger, shown here, in Topsail Beach. They continue a long tradition of drawing people to our beautiful island paradise. (Courtesy of Mary Meece and Paula Conley.)

TOPSAIL ISLAND

BJ Cothran

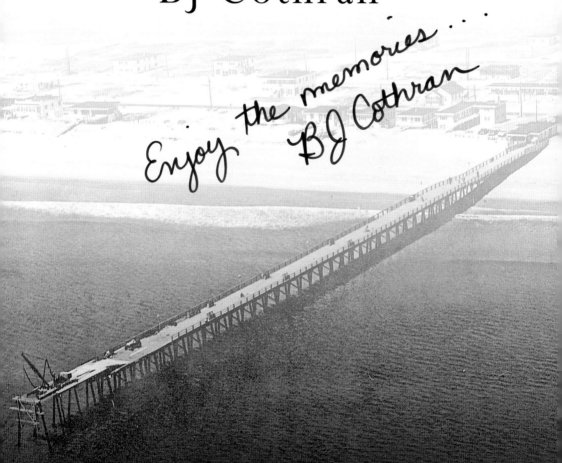

Enjoy the memories . . . BJ Cothran

For my darling beach girls, Chandler and Mary Grace, and their parents, Jessica and Tony. May they have sand in their shoes forever. And for Jack. He knows all the reasons why.

ON THE FRONT COVER: All of the modern photographs were taken by BJ Cothran, including the cover shot of the much-loved swing bridge that has welcomed islanders to Topsail for over 50 years. Construction of the current swing bridge was well underway in 1954 when Hurricane Hazel hit the island. The storm ripped the Sears Landing pontoon bridge from its moorings, and it had to be pulled back into place and repaired. (Courtesy of Phil Stevens and the Wayne Reynolds family.)

ON THE BACK COVER: J. G. Anderson Sr., one of the original developers of Topsail Island, was a visionary, a man with a dream for what an undiscovered spit of sand could become. His quirks were many—from his signature wagon to the neon sign on top of his office building to his penchant for bright-orange everything—but his mark on the island is unquestionable. (Courtesy of Phil Stevens and the Wayne Reynolds family.)

Contents

ACKNOWLEDGMENTS

There are so many people who have touched the pages of this book before it was ever printed that it will be hard to thank them all sufficiently. I usually end with thanking my husband, Jack, for all he does to support me, but this time, indulge me as I express my heartfelt gratitude to him at the top of the list. Thank you for directing traffic around me as I stood in the road to get many of the "now" shots for this book. Thank you for understanding as I spread photographs from one end of the house to the other. And thank you most for all of those things you did to keep our lives going as I lost mine in the writing process. I know it has been said before, but I couldn't have done it without you.

For all of you and all of the things you did to help breathe life into this project, thank you. At the risk of forgetting someone, I am going to mention those who went above and beyond, apologizing now for anyone I might leave out: Monte Baker, Jean Beasley, Anne and Dick Bishop, Howard and Pat Braxton, Cecile and Ed Broadhurst, Jean Brown, Sterling and Sterleen Bryson, Jim Cavender, Kathy and Andy Cavender, Graham Cole, Janeise and Sam Collins, Sandra Davis, Angelo Depaola, Steve and Robbin Dunthorn, Lori Fisher, Kristin and Grier Fleischhauer, Rachael Gaines, Diane Geary, Bernice Guthrie, Zander and Sabrina Guy, Janie Hauser, Mike and Judy Hendy, Roland Jack Howard, Nancy and J. R. Howell, Charles Hux, Connie Finney and Gerald Bennett at Johns Hopkins University Applied Physics Laboratory, Frances Keir, Jacob Lea, Becky and Fritz Lenker, Russell Bryan Lewis Jr., Jean Luther, Susan and Paul Magnabosco, Cathy and Doug Medlin, Mary Meece, Missiles and More Museum and the Topsail Island Historical Society, Rose Peters, Christopher Rackley and Lewis Realty, Michelle and Wayne Reynolds, Julia Barnes Sherron, L. D. Smith, David Stallman, Bobbie and Bill Stamper, Phil Stevens, Nickie Valerio, Jim Williams, Doris Jenkins, and Betty Sue Yopp.

It is important to thank my first and now former editor, Maggie Bullwinkel, who saw the vision for this project even before I had the time to think about it. Maggie was promoted to Southern editor with Arcadia but left me in good hands with my new editor, Lindsay Harris, who has tirelessly answered all of my technical questions with a smile. It has been a pleasure.

INTRODUCTION

Topsail Island changes like the shifting sand, moving a little here and there with every wave, every tide. The very shores her communities are built on are migrating constantly, as is the population. People come for a day, a week, or a season. They bring their children and grandchildren back again and again, hoping to share with them the special nature of this place.

This book is about changes. Sometimes they are subtle, while other times catastrophic. Many of the houses and businesses in our towns have been here, often in the same building, for decades. Or one structure may have been home to several different families or businesses, all with their own personal history and memories. Either way, people notice when a new sign goes up, a door is painted, a roof is replaced. By the shear smallness of Topsail's numbers and the fact that there are few main roads in most of the island towns, people pass the same places day in and day out and grow to feel they are a part of the landscape that makes this area unique.

And yes, by the very nature of living at the edge of the Atlantic Ocean, sometimes the changes are catastrophic. People here live with hurricanes and storms and nor'easters. They tolerate the uncertainness of their existence and know with all certainty that one day they may have to build back or start over. Some have done it time and again and will do so again, while others decide they do not have the fortitude to battle with Mother Nature. But that is the price for living life in a coastal area.

The beauty is that Topsail also remains much the same. Her people are loyal, returning year after year, season after season, to enjoy the beaches and waters that draw us in and make us want to stay forever. Each town—Sneads Ferry, North Topsail Beach, Hampstead, Surf City, and Topsail Beach—has its own personality, its own distinctive history. This book is not so much a complete history of these communities as a documentation of the many changes, big and small, that take place every day, every year. It is a glimpse into Topsail's past and a look at her present. For those with saltwater in your veins, you know it is worth it.

TOPSAIL BEACH

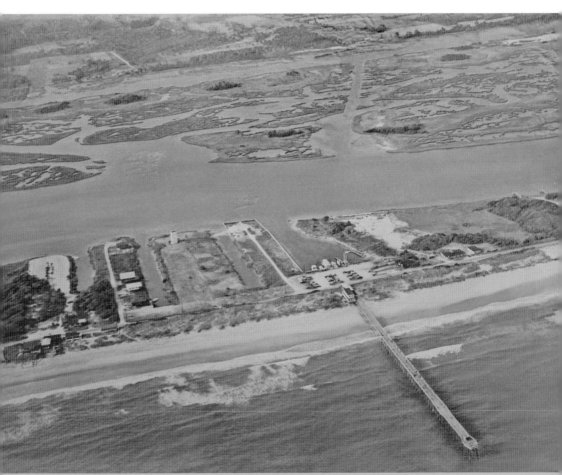

What is known as Harvey's Cut is clearly visible here cutting a path across the waterway from the mainland to the island. The story goes that the cut was made while Harvey Jones worked on the Atlantic Intracoastal Waterway (AIW) project. The photograph also shows the Dolphin Pier and marina, as well as the Jones Apartments that were, in part, old army barracks. (Courtesy of the Graham Cole family.)

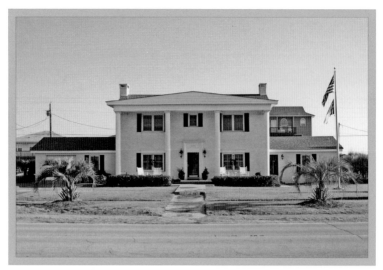

"One of the nicest places to live this side of heaven," is how New Topsail Beach was advertised in the late 1940s. J. G. Anderson Sr., one of the original developers of Topsail, purchased the land for his new community and built this house for his wife in the style of her Florida home. Past owner Phil Stevens used it as a residence and for Sea Path Realty's office. Today Michelle and Wayne Reynolds and family call it home. (Courtesy of Phil Stevens and the Wayne Reynolds family.)

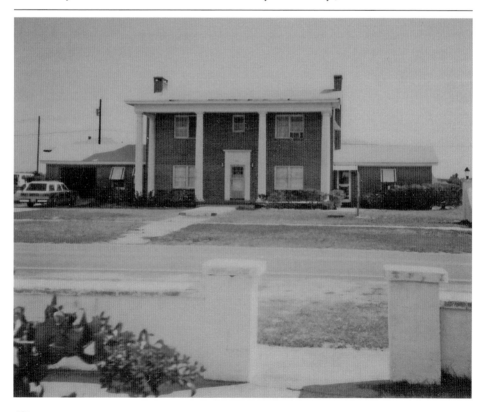

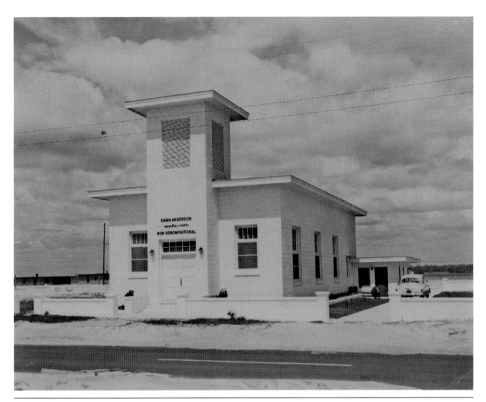

The Emma Anderson Memorial Chapel is a non-denominational church, originally funded through the efforts of developer J. G. Anderson Sr., who offered lots to buyers with the stipulation that they pay 10 percent of the purchase price to the "Church Fund," a practice the IRS eventually stopped. Even today, a different visiting minister uses the church's parsonage for a week and in return preaches on Sunday. The chapel has expanded to include year-round services, two services in season, and additional property. (Courtesy of Phil Stevens and the Wayne Reynolds family.)

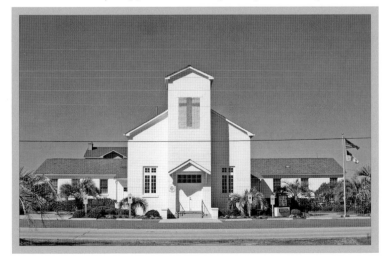

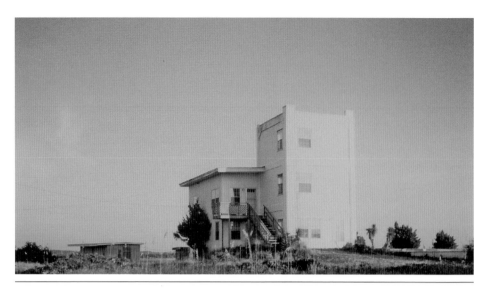

At the corner of Hines Avenue and South Anderson Boulevard stands the only Operation Bumblebee tower south of the Assembly Building where rockets were stored and assembled. Known as Tower One, the structure was converted into a home, shown here, by the Bordeau family in 1949. Current owners Taye and Lloyd Bost bought the tower home in the early 1990s and renovated it into a showplace that has been featured on a Home and Garden Television show called *Building Character*. (Courtesy of Missiles and More Museum.)

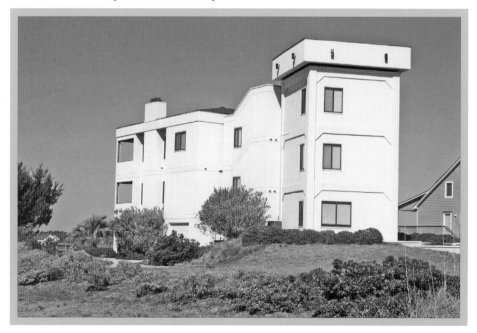

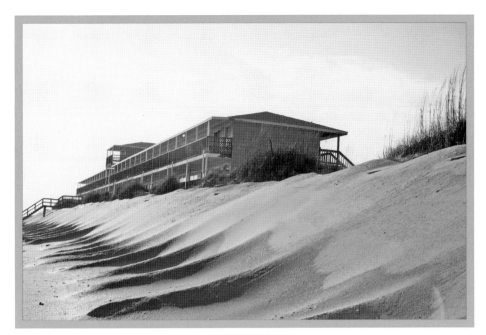

The Sea Vista Motel, located at 1521 Ocean Boulevard, is geographically the last oceanfront motel on the south end of the island. In August 1981, the motel was converted into the island's first motelominium—a motel where each room is individually owned yet managed collectively, like a motel—and remains so today. Each room is privately owned and decorated, but the property as a whole is managed as a motel with rooms available by the night or week or longer. After storm damage, the bottom level was removed, and the house next door was moved. (Courtesy of the Jim Cavender family.)

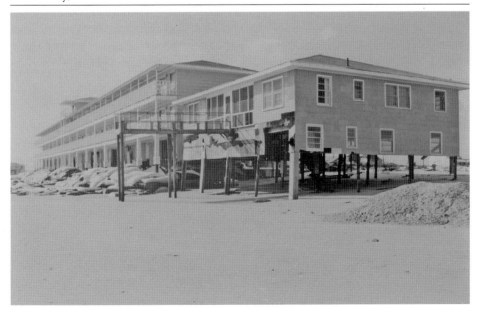

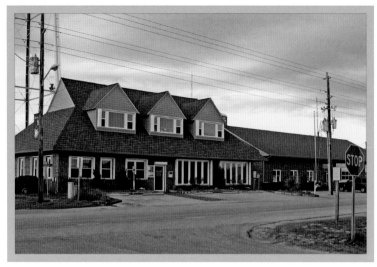

The Esso gas and service station was located on South Anderson Boulevard and Crews Avenue. Today the Topsail Beach Town Hall, built in the 1950s, sits on the site. In the early years, bays for a fire truck and ambulance existed in the current meeting room. The bays were enclosed in the 1970s, and a second floor was added in the 1980s. The mayor is Howard Braxton, the town manager is Steve Foster, and the commissioner and mayor pro-tem is Bobby Humphrey. (Courtesy of Paul and Susan Magnabosco.)

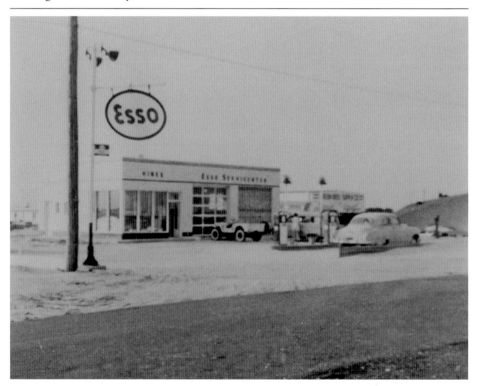

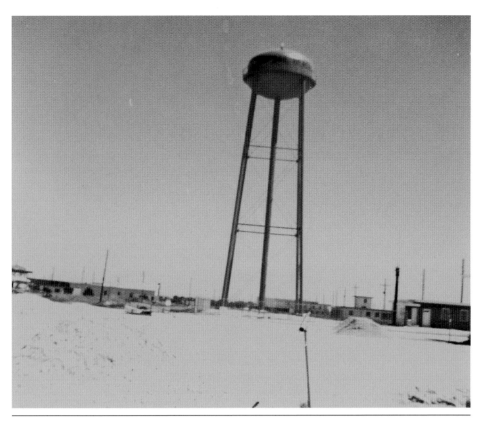

The downtown area has grown over the years since the water tower was built in 1972. The tower, with a capacity of 100,000 gallons, was painted a bright red in the early days and is now replaced with a milder blue. This photograph was taken of the South Beach Yacht Club and Marina from the parking lot of the town's new public boat ramp, named Bush's Marina after Bobby Bush, who ran Bush's Repair Center on the site from 1968 to 2005. (Courtesy of the Nancy Howell family.)

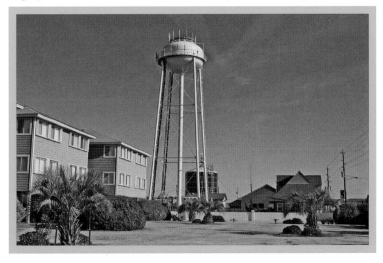

The first Sunday school class for the Emma Anderson Chapel was held in August 1949 in the family home of Steve and Lib Keith Mallard. The Mallard cottage faced South Anderson Boulevard and sat in the lot beside the Quarter Moon Bookstore. Behind the lot, facing Carolina Boulevard, sits the donated house that is today the interns' cottage for the Karen Beasley Sea Turtle Rescue and Rehabilitation Center. Interns help the staff work with endangered and threatened sea turtles. (Courtesy of Dr. and Mrs. Howard Braxton.)

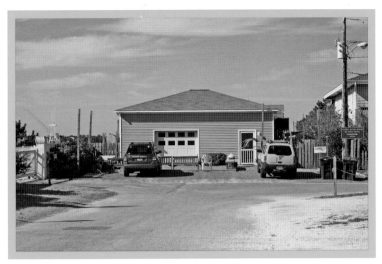

The Topsail Turtle Project grew from Karen Beasley's dream of helping endangered sea turtles. After Karen's death in 1991, her mother, Jean Beasley, expanded the project into the Karen Beasley Sea Turtle Rescue and Rehabilitation Center. Funds were raised to build the hospital, which is solely supported by donations. The project is again growing, with plans for a new hospital in Surf City. The land has been secured on the mainland, and funds are being raised to make the next part of the dream a reality. (Courtesy of Missiles and More Museum.)

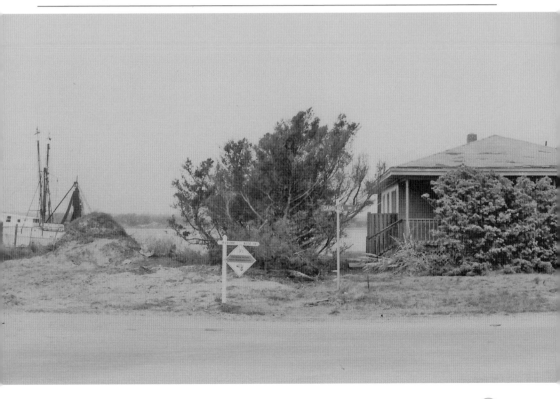

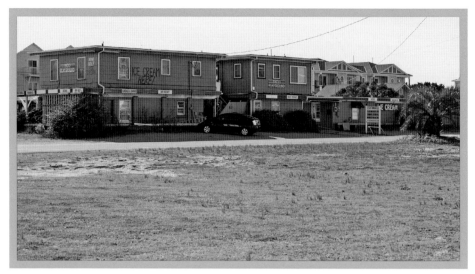

From left to right, former Topsail Beach mayor Bill Stamper and his wife, Bobbie, enjoy the second Autumn with Topsail Festival, held in 1989, with their daughter Susan Smith, her husband, Scott, and the Stampers' granddaughter Stacey. The AWT Festival is held annually to raise money for the upkeep of the historic Assembly Building. Across the street is the Patio Playground, an entertainment complex that continues to offer miniature golf, arcades, and concessions to visitors and residents alike. (Courtesy of Sterleen Bryson.)

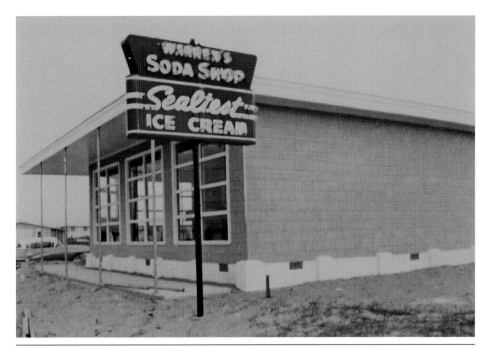

In the early 1950s, William Warren and his sister Rachel Warren Magnabosco opened Warren's Soda Shop, the first fountain on the island. The popular soda shop moved in 1959 from Crews Avenue to its current location at the corner of Davis Avenue and South Anderson Boulevard. Warren's is now the Beach Shop and Grill, a full-service restaurant and bar with an adjoining gift shop, owned and operated by Jeff and Cheryl Price. (Courtesy of Paul and Susan Magnabosco.)

This glimpse of downtown shows a partial view of the Skating Rink and Topsail Beach Post Office building, owned by Doris and Sonny Jenkins, along with Sonny's woodworking shop, where he sells his popular birdhouses. Next door, Topsail Realty, owned by Randall K. and Jane Leeseberg, has been in business for over three decades. Past the motel that was torn down in recent years, notice the original white pillar marking the town's entrance, which is still on site today. (Courtesy of Missiles and More Museum.)

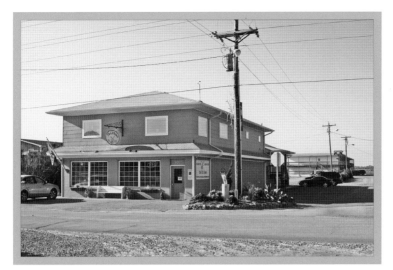

A large neon sign sat on top of developer J. G. Anderson's real estate office at the corner of South Anderson Boulevard and Davis Avenue. Several businesses came and went until Louis and Mary Lou Muery opened the Gift Basket there in the 1970s, so named by their son because Mary Lou really loved baskets. Mike and Linda Hendricks and Ron and Mary Jo Pyles bought it in 1996 and sold it in 2002. Today the Gift Basket's owners are Grier and Kristin Fleischhauer. (Courtesy of Paul and Susan Magnabosco.)

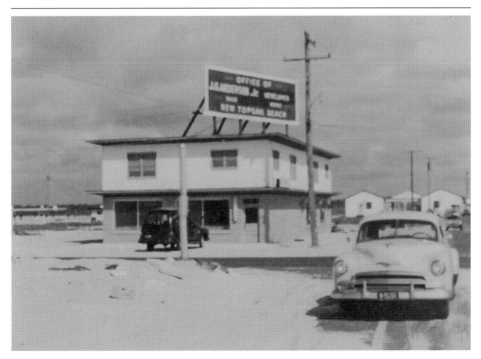

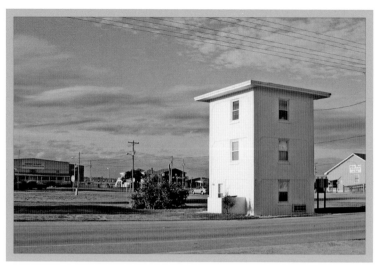

During Operation Bumblebee, the Firing Point Control Tower housed the communication equipment that connected the control tower with the photographic towers. It is on the National Register of Historic Places because of its military significance. Purchased by J. B. Brame in the late 1950s, the tower was converted into a residence. Across the street, what began as Home Port is now Home Port Restaurant again. The building, owned by the Cherry family, has housed several businesses in this location over the years. (Courtesy of David Stallman and *Echoes of Topsail*.)

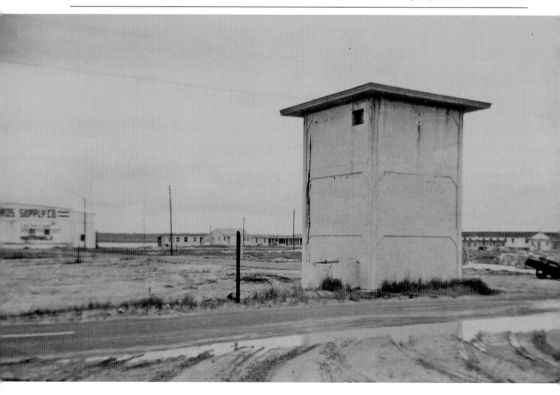

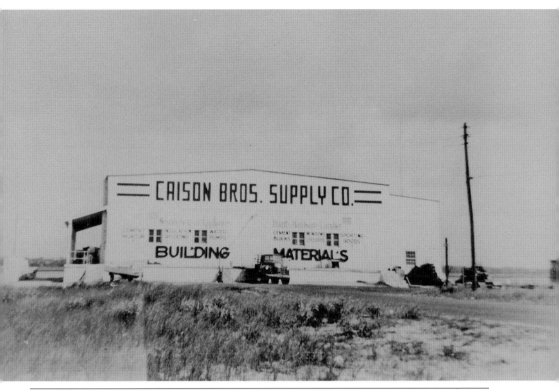

The Assembly Building was constructed for the assembly of rockets during Operation Bumblebee, a secret government project in the late 1940s by the navy's Bureau of Ordinance in conjunction with the Applied Physics Laboratory of Johns Hopkins University. Built to minimize any explosion, the structure is relatively unchanged. Over the years, it housed many businesses, including Caison's Building Supply. It is currently home to the Topsail Island Historical Society and the Missiles and More Museum. (Courtesy of Paul and Susan Magnabosco.)

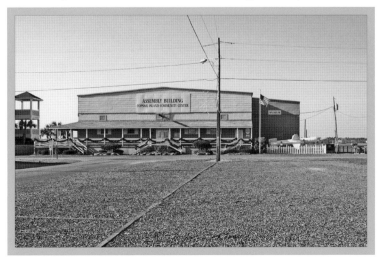

The rounded-top building with a bombproof bunker, now a part of the Jolly Roger Motel and Pier, was a leftover from Operation Bumblebee days. The concrete patio, shown here, was the launching pad for over 200 ramjet firings that took place from 1946 to 1948. In the early days after Operation Bumblebee, Slim Anderson, J. G. Anderson's son, converted the building into the Sun N Fun Recreation Hall, which included a skating rink, arcade, trampoline area, and a post office. (Courtesy of David Stallman and *Echoes of Topsail*.)

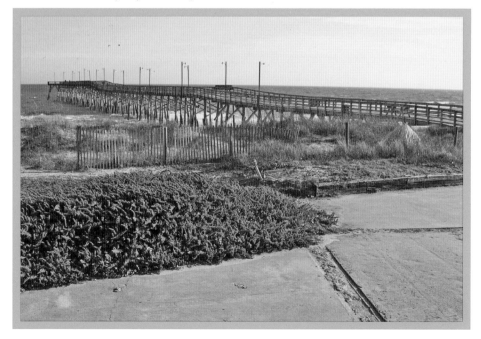

Angelo "Deep" Depaola is shown here on the Jolly Roger Pier in August 1979 with his catch, a 63-pound tarpon. But the prize for biggest fish goes to a 112-pound tarpon he caught off the end of the pier. After a distinguished career in the military, Depaola started a new career with the fire department at Camp Lejeune, where he served as fire chief from 1970 to 1975. He also served the Topsail Beach Volunteer Fire Department for nearly 25 years. (Courtesy of Angelo Depaola.)

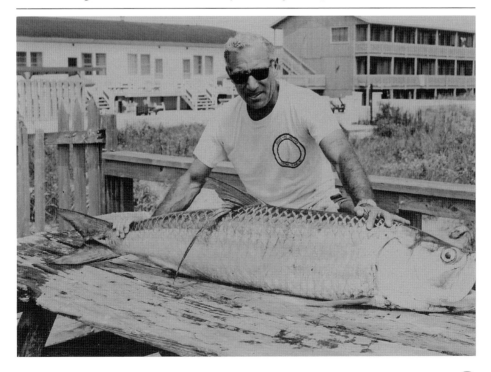

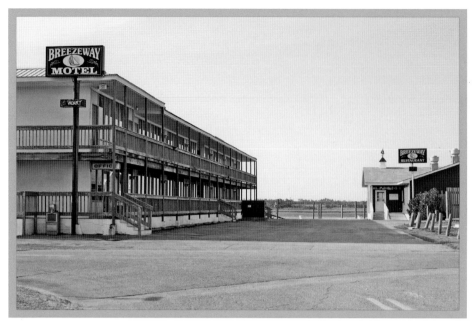

The army's mess hall and barracks became the island's first motel, the Breez-Way Inn and Café, owned by J. G. Anderson Sr. Waitus Bordeaux and his wife ran it in 1949 for a couple of years before Eunice and Dewey Justice took over. Dewey Justice was mayor of Topsail Beach from 1967 to 1968. They sold out in 1971 to Dr. M. L. Cherry. William "Bill" and Kathryn Merrit "Kathy" Cherry own and operate the business, now called the Breezeway Restaurant and Motel. (Courtesy of Phil Stevens and the Wayne Reynolds family.)

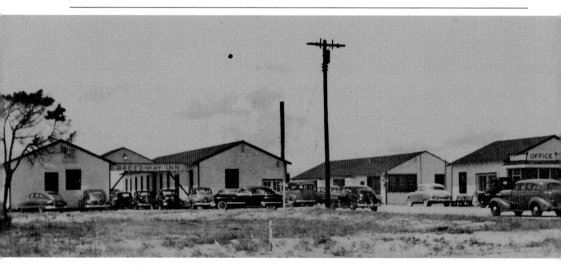

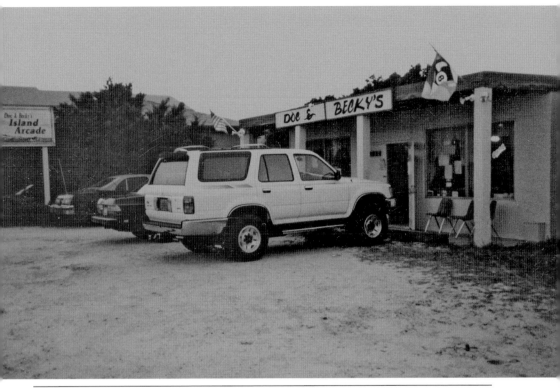

Quarter Moon Books and Gifts began in the office next to Island Treasures. Lori Fisher bought the business and then moved it to its current location in 2000, when she and Pat Dunn bought the building. Dunn sold her interest to Fisher in 2002. Quarter Moon has expanded to include a coffee bar, outdoor seating, and Internet access. The former business at this location was Doc's Island Arcade, started in 1991 by Kenneth Ayers and his wife, Jayne. Becky Lenker joined the arcade business in 1993. (Courtesy of Becky and Fritz Lenker.)

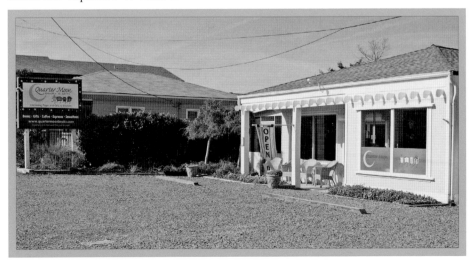

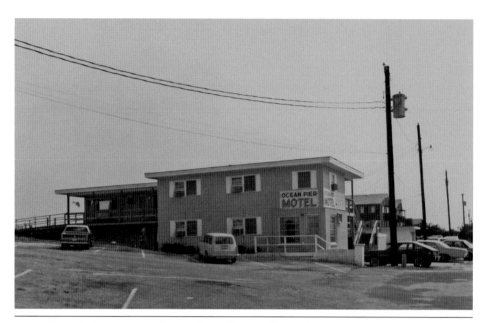

Lewis Orr, the first mayor of Topsail Beach in 1963, built the Ocean Pier Motel for Clarence Smith and even ran it, along with several other business ventures, for several years. In time, the Ocean Pier Motel (shown here) became the Ocean Pier Inn, but the small motel was torn down in recent years and replaced with duplexes built on the site across from the Patio Playground and next to the Jolly Roger Pier. (Courtesy of Charles Hux.)

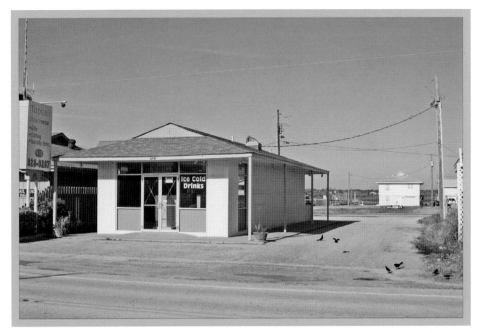

The Jif Freez building was built in 1974. Several different owners ran the business before it was sold in 1980 to Nickie and Larry Valerio. For over 20 years, they sold ice cream, pizza, tacos, and more to islanders and visitors alike, with their famous "Jif burger" being one of the most popular items on the menu. The Valerios sold it to the current owners in 2002, and it has since housed a seafood house and a souvenir shop. (Courtesy of Jean Brown.)

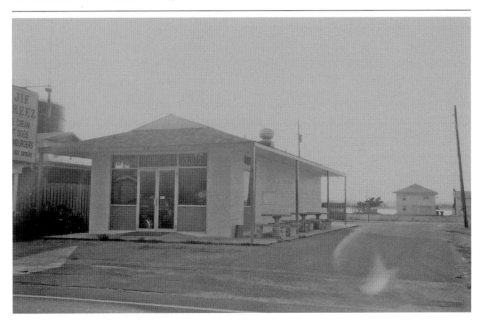

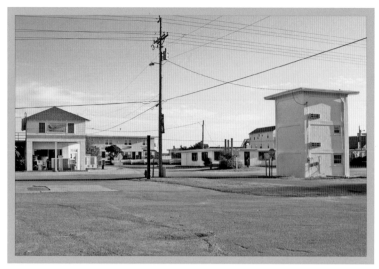

Built in 1949, Godwin's New Topsail Market was the first general store in the area. James Averon Godwin and Esther Godwin ran the business, first as managers and then as owners. Still owned and operated by the Godwin family, the store was taken over and run by their son Bill and his wife, Mary, in 1976. It is not every day one sees a house rolling down the street, but moving houses has grown more popular since the time the Jim Cavender family moved this house from oceanfront to Bridgers Avenue. (Courtesy of the Jim Cavender family.)

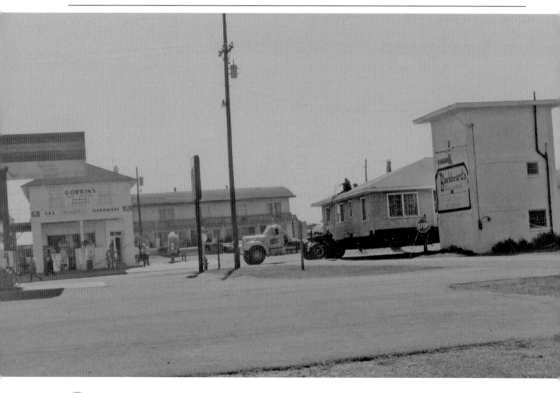

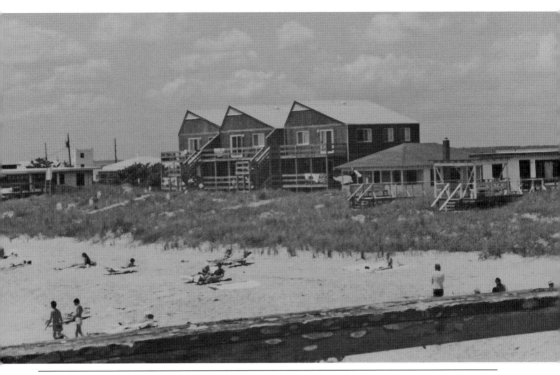

This shot of the Whitecaps condominiums was taken from the Jolly Roger Pier more than 25 years ago. Today two new luxury duplexes called the View of Topsail are almost complete, sitting oceanfront in the same location where Whitecaps was torn down. The homes shown in the old photograph are good examples of typical beach cottage construction, where homes had flattop roofs. In some of the older houses, the flat roofs can still be found under the pitched ones seen today. (Courtesy of Charles Hux.)

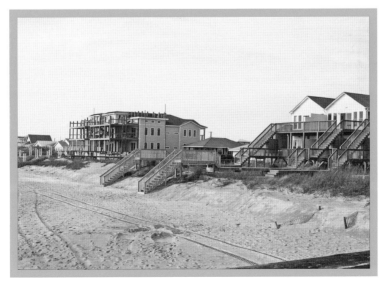

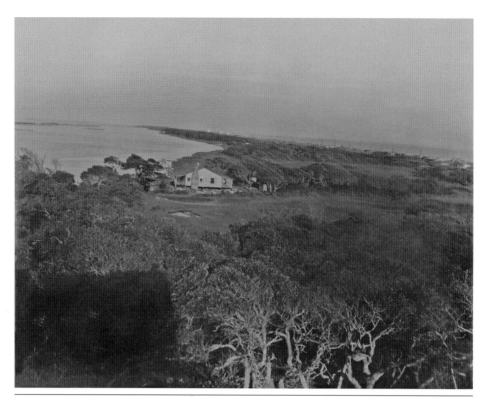

Harvey Jones and his wife, Elsie Jones, floated a shack over to the island and maintained a residence in the area that is now Queen's Grant Condominiums for a year so that the Army Corps of Engineers would build a bridge connecting the island to the mainland. The shack, arguably the first residence on Topsail, was eventually replaced by the house shown here. All materials used to build it had to be floated over, including the lumber. (Courtesy of the Graham Cole family.)

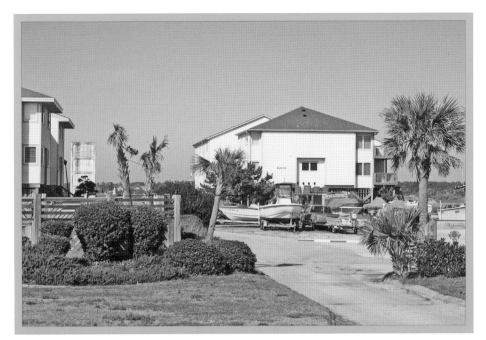

TowerTwo is perhaps the best representation of the way the towers looked in 1946 during Operation Bumblebee. In 1993, the tower was placed on the National Register of Historic Places. Tower Two is located sound side at Queen's Grant Condominiums, an expansive complex with buildings on the ocean and sound. The heirs of Harvey Jones sold the tower to the present owners in the 1970s. Shown here is longtime resident Monk Fussell preparing for one of the many barbecues held in the community. (Courtesy of Sterleen Bryson.)

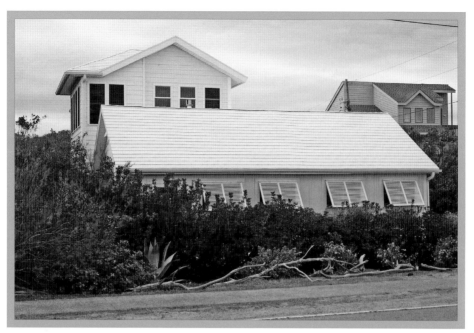

The Mayrand cottage, called the 5th Chip, was built in 1958 by Clifton Howard. In 2002, a major renovation was undertaken, with the final design by William Dalrymple influenced by what is now called the North Carolina Sustainable Building Design Competition, which was founded by Phil Mayrand and Appalachian State University. The design was built around a beautiful stained-glass window believed to date back to the 1860s. New owners Jean McLendon and Carol Holcomb now enjoy the 5th Chip. (Courtesy of the Mayrand family.)

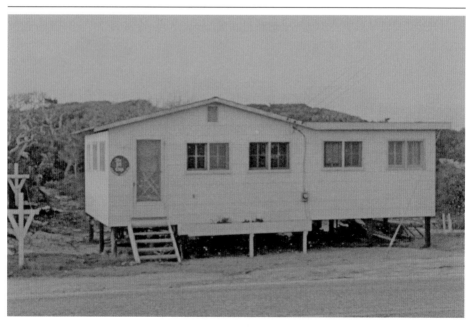

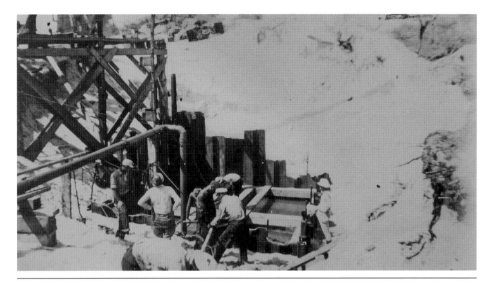

The Carolina Exploration Company headed up a search for gold from 1937 to 1941 on land belonging to Judge John Thomas Bland. Work began with shovels, but eventually well-drilling equipment was brought in to achieve the 40-foot shaft. The project ended abruptly and disappeared overnight with no proof of any gold ever being found. What remains of the "Gold Hole" still sits on the Mayrand property, now owned by former historical society president Cecile Broadhurst and her husband, Ed. (Courtesy of David Stallman and *Echoes of Topsail*.)

Over the years, sound and ocean access areas have been added up and down the island. This shot was taken from the deck of Pinfish, a home moved from the oceanfront near Sea Vista to Bridgers Avenue, where it still sits today. See page 32 for a photograph of the house en route on South Anderson Boulevard. Moving houses on and off the island dates back to the days when leftover army buildings from Camp Davis were brought over and used as rentals or businesses. (Courtesy of the Jim Cavender family.)

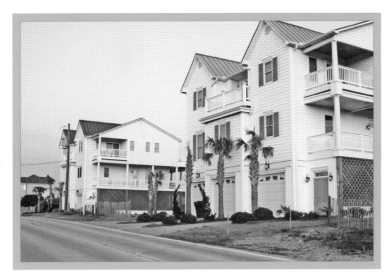

According to a *c.* 1950 postcard, the Topsail Motel consisted of "twenty-one modern units with kitchenettes plus two new three-bedroom cottages." This photograph was dated early 1954, which was before Hazel, a hurricane that did substantial damage to the motel as well as the island. Located oceanfront on North New River Drive, the motel was only recently torn down in the last couple of years and replaced with residential lots and two luxury duplexes. (Courtesy of Becky and Fritz Lenker.)

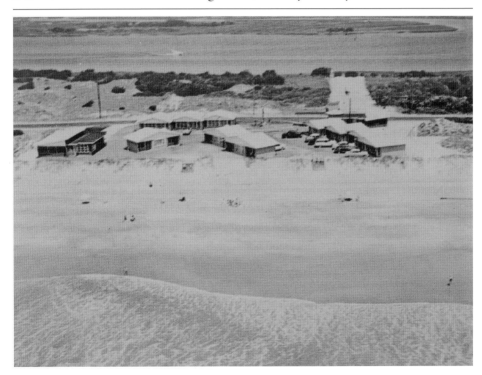

This delightful island cottage was built in 1949–1950 and is typical of the era. For many decades, cottages were used for vacations and summer residences and were often closed up in the cold winter months. Walter "Bing" Keir and Nellie Gray Hunt Keir bought it in 1968. Their daughter, Frances A. Keir, continues to enjoy the house, situated on an island interior lot filled with stately live oaks that have weathered the storms over the years. (Courtesy of Frances A. Keir.)

CHAPTER 2

SURF CITY

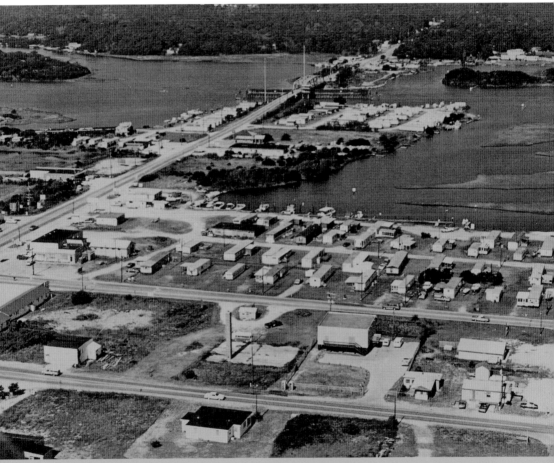

Surf City, the gateway to the island, was incorporated in 1949, making it the first official town on Topsail. This 1980s view shows how far the town had come in 30 years, a long way from those first few abandoned military buildings that were its humble beginnings. David Lucas was the first mayor, and A. H. Ward was public works director and a commissioner. (Courtesy of Christopher Rackley of Lewis Realty.)

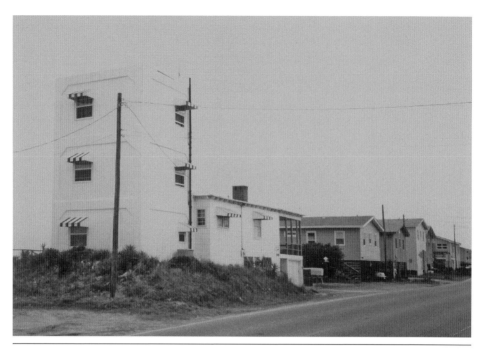

Tower Three, a remnant from Operation Bumblebee, is perched ocean side near the town line between Surf City and Topsail Beach. The heirs of an early owner, Judge John Thomas Bland, converted the tower into a home, shown here, in 1950 with an addition. Kenyon and Evelyn Ottoway traded property to acquire the tower in 1965. In September 1996, Hurricane Fran totally demolished the addition. Today the John Gresham family owns the tower, which remains virtually untouched since Fran. (Courtesy of Missiles and More Museum.)

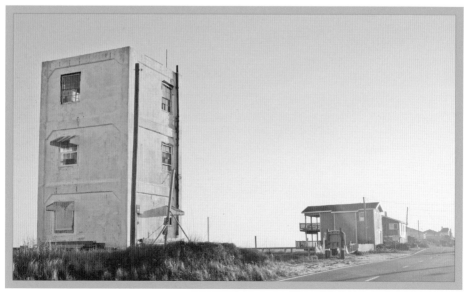

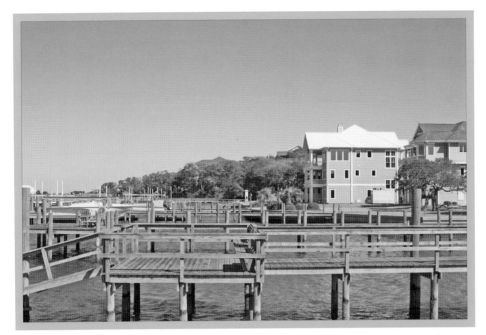

L. D. Smith and his brother Henry ran Seafood World, a thriving fish house that sold fish locally and to distributors up and down the Eastern Seaboard. Seafood World was built and operated by Ivey and Vernon Lewis in the late 1970s before they sold it to the Smith brothers, who ran it until 1995, when it was sold and vacation homes were built on the 1.7-acre site. A hand-painted sign—"Good Fresh Seafood is Our Biggest Bargain"—greeted visitors at the door. (Courtesy of L. D. and Henry Smith.)

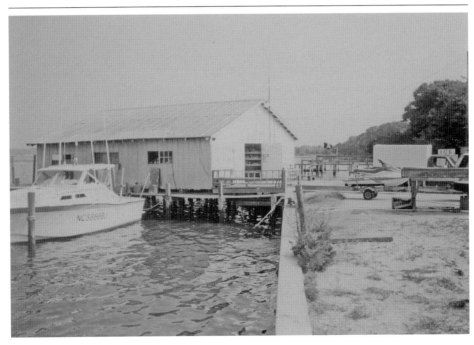

The Stubbs family owned one of the leftover Operation Bumblebee towers in the 1950s, even reportedly running a hot dog business out of the bottom floor for a time. In 1998, John West bought what was then a skeletal structure of Tower Four, shown here, and turned it into a beautiful home using the basic framework of the original tower. Tower Four is located south of what is called the S-curve traveling from Surf City toward Topsail Beach. (Courtesy of Missiles and More Museum.)

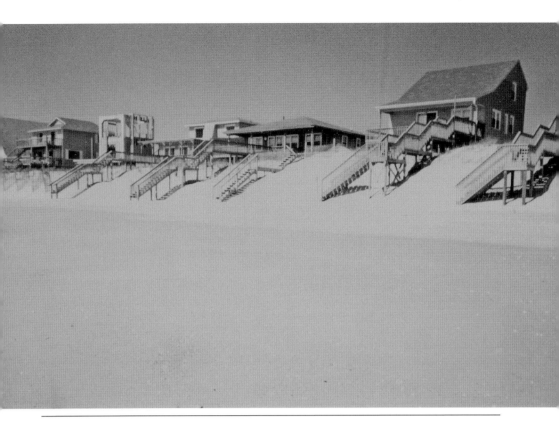

With space at such a premium, homes on the island seem to be constantly changing. Remodeling and adding on are popular alternatives. This quiet stretch of beach where Tower Four is located shows a good example of homes that have been lovingly maintained. Also notice the dune vegetation is much more established in the recent photograph, proof that the trend toward establishing and maintaining the dunes is gaining support. (Courtesy of Missiles and More Museum.)

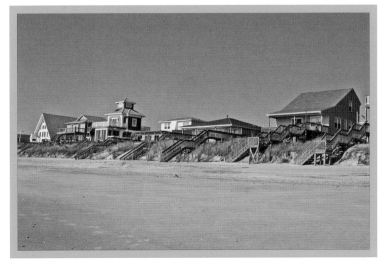

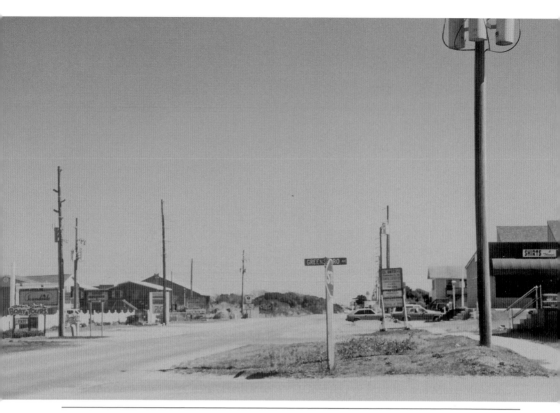

One thing that remains the same in this area of North New River Drive is the abundance of commercial businesses because of its close proximity to the swing bridge. Treasure Coast Square, owned by the Medlin family, has long been a shopping destination in Surf City. But a big change between the old and new photographs is the addition of the large building on the left, the new $1.8-million home of the Surf City Police Department. (Courtesy of Kristin and Grier Fleischhauer.)

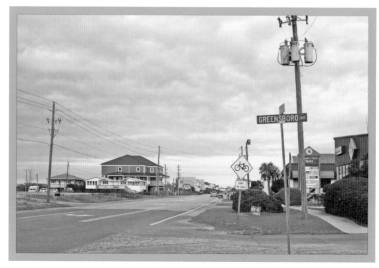

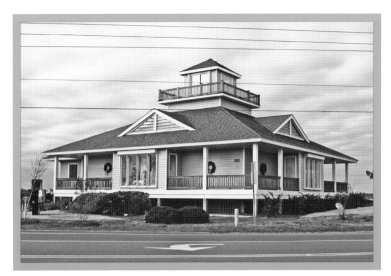

Kristin and Grier Fleischhauer, owners of the Gift Basket, bought the Topsail Island Trading Company in 2007 from Don and Jean Luther, who built the iconic building in 1992. The Luthers had previously owned the Ship's Wheel business, which was located in the two-story building where the Surf City Florist is today. Several businesses, including Studio One and the Surf City Motel, were located on the Topsail Trading property, and some of the old buildings were moved and used elsewhere on the island. (Courtesy of Kristin and Grier Fleischhauer.)

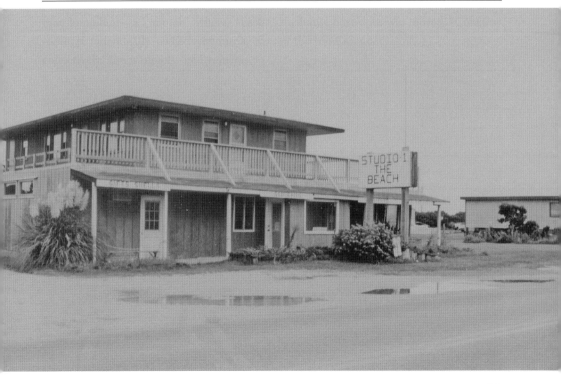

Owned by Margaret and Joe Paliotti, the rustic Pirate's Den was once an army building, like so many of the island's early structures. The restaurant burned down after a storm in 1993 and was not built back. For a time, Paliotti moved to Villa Capriani in North Topsail Beach. Their advertisement read, "Topsail Island's original Italian restaurant." Joe Paliotti served as mayor of Surf City from 1971 to 1972, from 1982 to 1987, and again from 1991 to 1993. (Courtesy of David Stallman and *Echoes of Topsail*.)

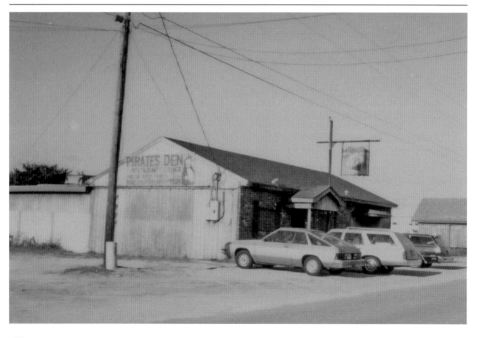

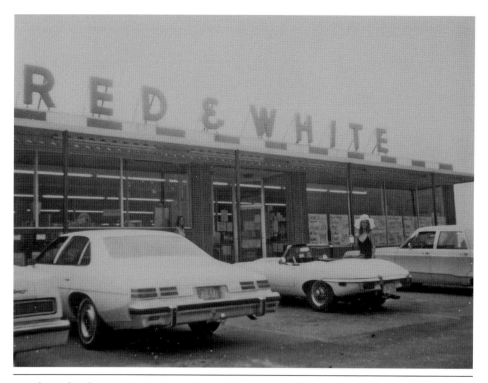

Ward Realty began in 1947 as Standard Realty and Construction by A. H. Ward. He was instrumental in the island's development and served as mayor of Surf City in 1954. Ward Realty has developed 19 subdivisions as well as the Red and White grocery, built in the 1960s. Archie Williams purchased the Red and White in 1967, turning it over to his son Don Christopher Williams in 1983. James E. "Jim" Williams Jr. (Don's son-in-law) has managed the store, now an IGA, since 1991. (Courtesy of Jim Williams.)

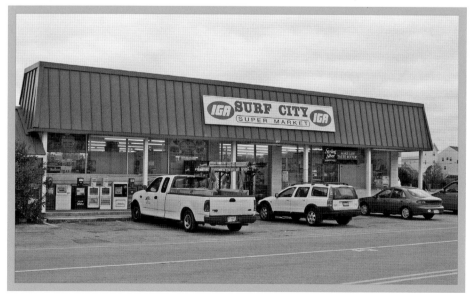

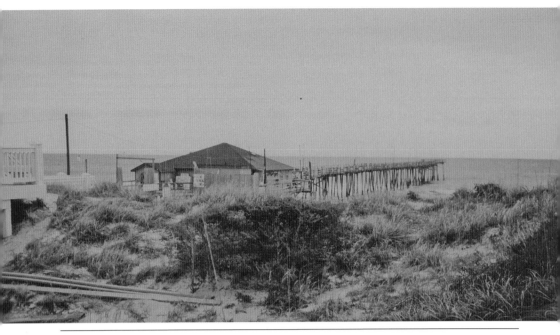

Built in 1948, Surf City Pier, located at 112 South Shore Drive, was Topsail's first ocean fishing pier. A storm took out the pier in 1954, and it was replaced by a steel one that rusted in time and had to be replaced by wood. Since 1973, the Lore family has owned and operated the pier. It was destroyed by Hurricane Fran in 1996 but was totally rebuilt and reopened in 1997, complete with a tackle shop and grill. (Courtesy of David Stallman and *Echoes of Topsail*.)

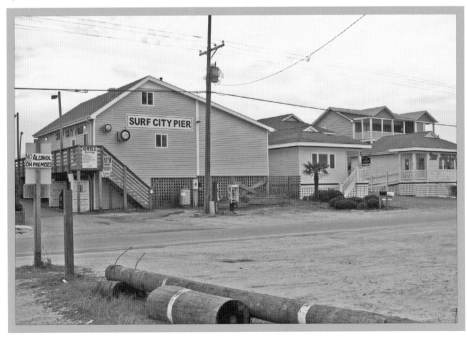

Charles "Charlie" and Bettie Medlin opened Coastal Ice Company in 1952 and enlarged the building to accommodate a grocery store in 1956, then a hardware and gift store in 1959. In 1981, their son Doug remodeled and it became East Coast Sports. The old structure was replaced in 1999 with the Fishing Village, which houses several businesses, including Island Real Estate, operated by Cathy, Doug's wife. The Art Gallery, the original central telephone building, was moved off island, but the business relocated to 121 South Topsail Drive. (Courtesy of the Medlin family.)

Tower Five is located ocean side on North Shore Drive in the heart of Surf City, a few blocks from the Surf City Pier. Extensive renovations by owner Ken Richardson have been made since his purchase of the property in 1994. The original white tower is still easy to spot from the beach. During Operation Bumblebee, the photographic towers sported flattops surrounded by railings. Today Tower Five has a penthouse in place of the observation deck. (Courtesy of David Stallman and *Echoes of Topsail*.)

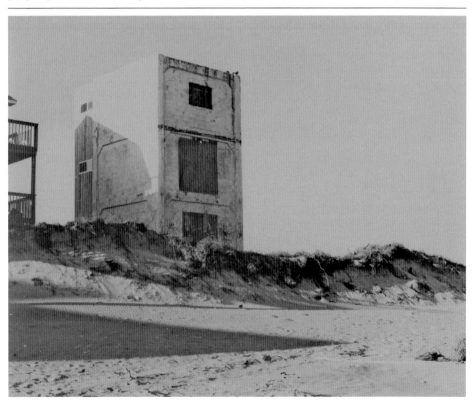

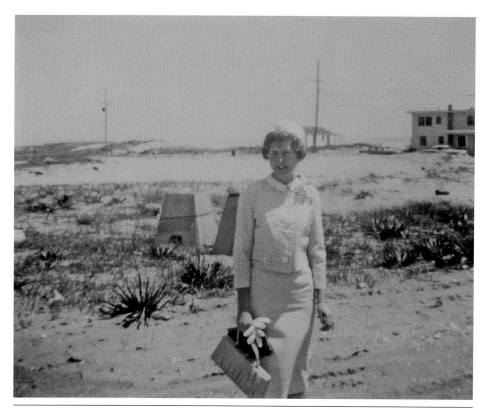

It was a clear view all the way to the ocean in this shot of Diane Geary with what is now North Shore Drive behind her. Today luxury duplexes line the oceanfront all the way to Daddy Mac's restaurant. The photograph was taken from the parking lot of Spinnaker Surf Shop, which sits next to Mollies Restaurant and the Bank of America. The Surfside Motel, shown here, managed by Blizzard's Anchor Inn, replaces the Sonny B for oceanfront accommodations. (Courtesy of Diane Batts Geary.)

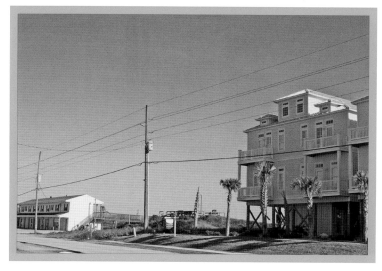

Diane Geary is standing in front of one of the old army warehouses in about 1953, which shows just how desolate the area was then. Although the building was torn down in the 1970s, the brick chimney remains today. Her father, R. T. "Roland" Batts, was mayor of Surf City from 1957 to 1964, when he died, and his wife, Sally, finished out his term. In the distance are dry docks at the Beach House Yacht Club and Marina. (Courtesy of Diane Batts Geary.)

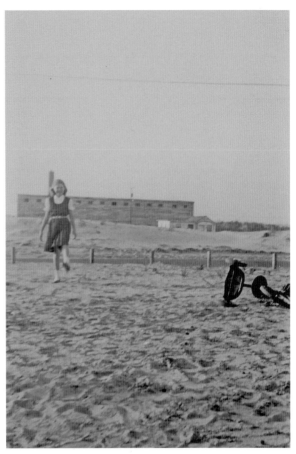

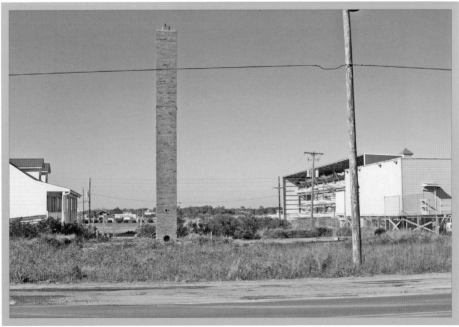

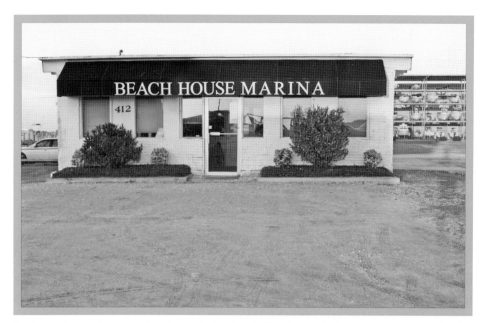

Evelyn Mayrand opened Mayrand Real Estate in 1962. Her son, Phil, took over in the late 1970s and added a partner, Peggy Lewis, in 1987. Previously Lewis worked with Edgar Yow, the attorney instrumental in developing Ocean City Beach. In 1988, Lewis bought out Mayrand and in 1992 changed the name to Lewis Realty Associates, Inc. Beach House Marina is now in the former Lewis Realty location on the causeway. Lewis is now around the corner on North New River Drive. (Courtesy of Christopher Rackley and Lewis Realty.)

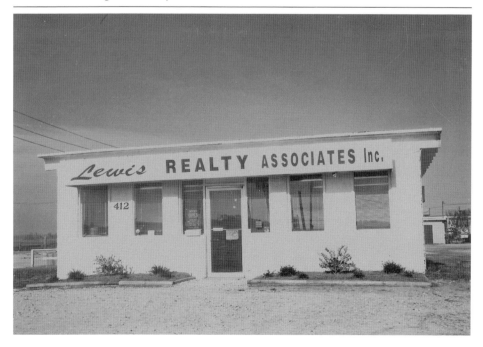

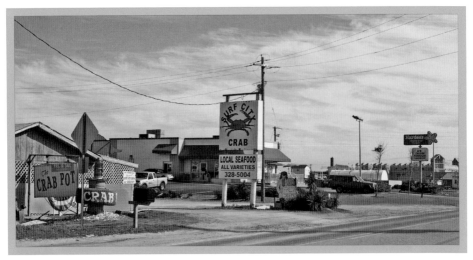

Roland Avenue has always been a commercial hub. Before the high-rise bridge was added in North Topsail, it was the only road onto the island. Of particular note is the first fast-food chain establishment on the island, Hardees, which sits on a prime waterfront lot. Next door are the Crab Pot, a casual restaurant and bar, and Surf City Crab, a fresh seafood market that has served the area for over 20 years, owned by Adrian Kugatow and J. M. Moseley. (Courtesy of Missiles and More Museum.)

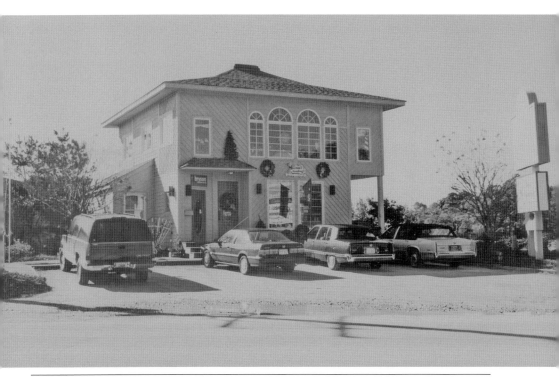

Bryson and Associates, a full-service real estate company, began in 1987. Siblings Sterling and Sterleen Bryson, longtime residents, have been active in many of the community organizations over the years. Bryson's is located in a distinctive building on the causeway just before the swing bridge, across from Sears Landing. In the 1990s, the front area and upstairs of the building housed an island favorite, bah! humbug!, a Christmas decor and gift store. (Courtesy of Sterleen Bryson.)

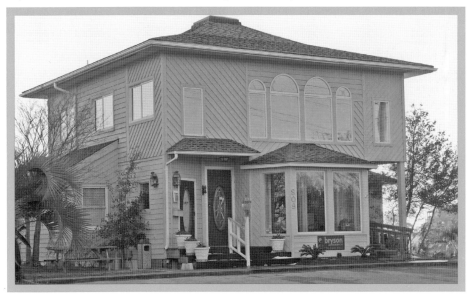

The island draws three distinct types of dwellers—ocean people, sound people, and canal people. Close-knit neighborhoods like the one on Ninth Street, shown here in the 1980s, are desirable because of their spectacular sound views and easy access by boat to the waterway. Many of the modest mobile homes that were prevalent in the early days of the island have been replaced with permanent homes, duplexes, and even multi-family dwellings. (Courtesy of Nancy Howell and family.)

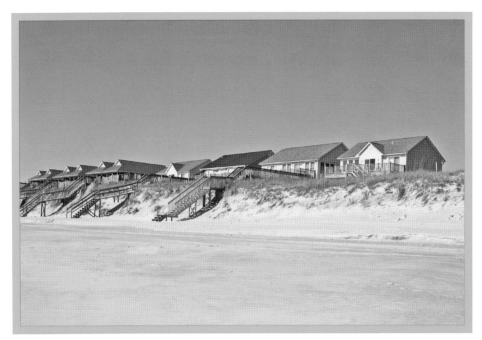

Charles "Charlie" and Bettie Medlin bought Barnacle Bill's Pier in 1966. Their children Dan, Doug, and Sue and their spouses helped run the entertainment complex complete with two restaurants, a campground, a motel, the Ship "Wreck" Room Oceanside Arcade, and the Island Hideaway Gift Shop, as well as the pier. The pier, destroyed in 1996 by Hurricane Fran, was located at 706 North Shore Drive. Today residences sit on the oceanfront part of the property, and the rest is undeveloped. (Courtesy of the Medlin family.)

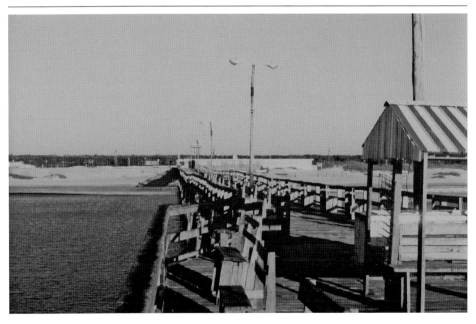

This photograph was taken of Diane Geary standing in the parking area of what was once a rental home and in recent years housed a novelty store, Ken's Gifts, prior to its closing in 2009. Today Shark Attack Souvenirs sits on the corner of Greensboro Street and North Topsail Drive in the area where early homes and the "cooler" ice cream shop and Laundromat were located. Across from Shark Attack is artist's Sandy McHugh's bright-pink Seacoast Art Gallery. (Courtesy of Diane Batts Geary.)

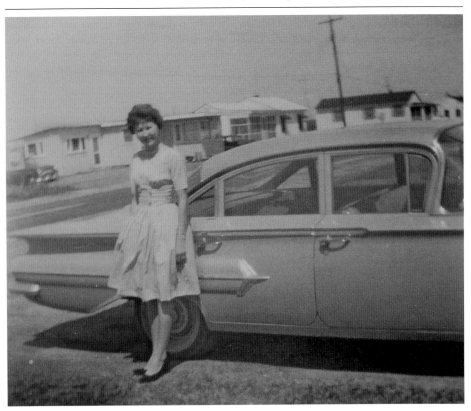

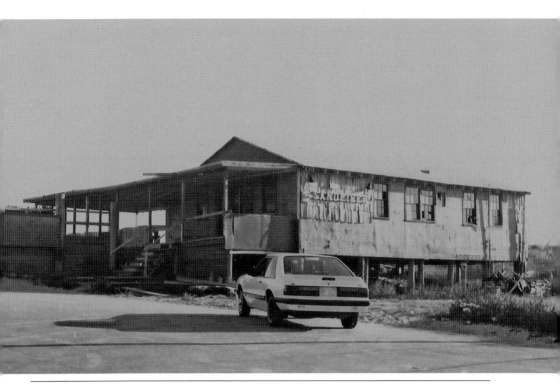

Buddy's Crab House sits at the end of the causeway road next to the Roland Avenue beach access. Sitting on the porch gives diners a great view of surfers and the Surf City Pier. An earlier restaurant, the Sandpiper Tarven (yes, it was spelled that way), had an advertisement that read, "Come to the Sandpiper and get lit," which pretty much explains its popularity. On the other side of the access is the new Surf City Welcome and Visitors Center. (Courtesy of David Stallman and *Echoes of Topsail*.)

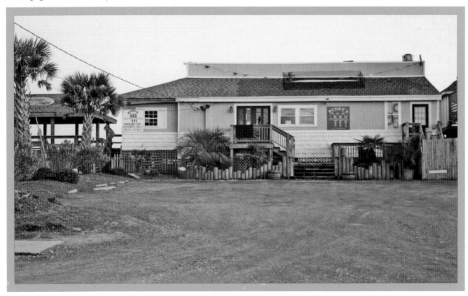

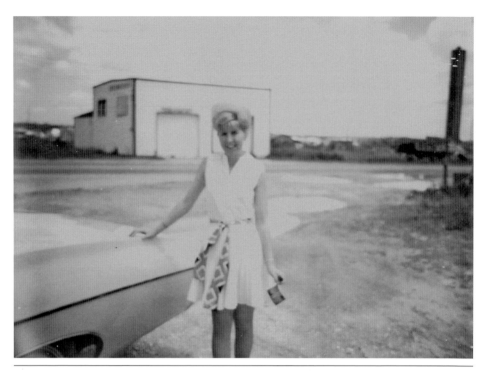

From 1948 to 1953, Roland and Sally Batts lived with their family in a leftover military firehouse, shown here in 1972. For a time, they ran a grocery store and post office out of the old building. Today Andy's Cheesesteaks and Cheeseburgers is located there. To the right past the chimney relic is the Embarq switching station. Shown here is Diane Geary, who owned the Ship's Wheel clothing and souvenir shop until 1987. (Courtesy of Diane Batts Geary.)

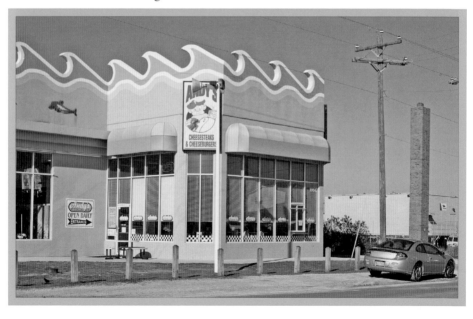

CHAPTER 3

NORTH TOPSAIL BEACH

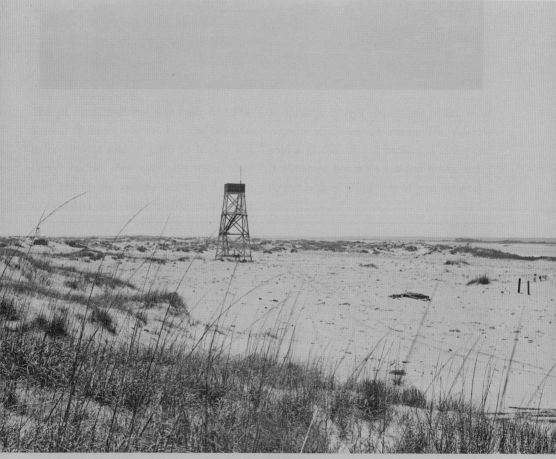

The island's third town was known as West Onslow Beach before being incorporated as North Topsail Beach in 1990. The North Topsail Shores development of the 1980s and Ocean City Beach, founded in 1949, are both now part of North Topsail Beach. This fire tower from early army days on the island shows how desolate the area truly was for many decades. (Courtesy of Johns Hopkins University Applied Physics Laboratory.)

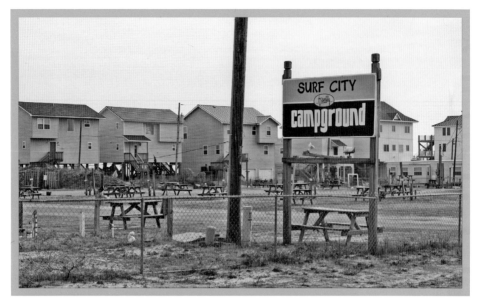

Actually located in North Topsail Beach, the Surf City Family Campground has been an island destination for decades. Shown here in the summer of 1977, the campground is often filled to capacity during the height of the season. Surf City's mayor, Zander Guy (1999 to the present), was one of the lifeguards stationed in front of the campground from 1968 to 1970. This current shot was taken during the winter, when many campers move off island until warm weather draws them back again. (Courtesy of Zander and Sabrina Guy.)

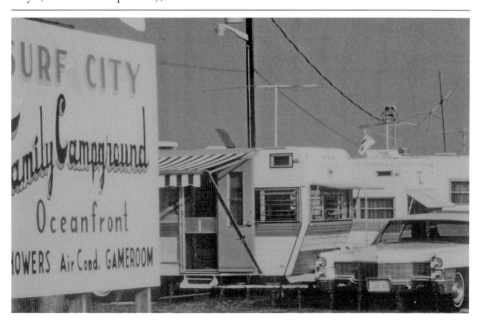

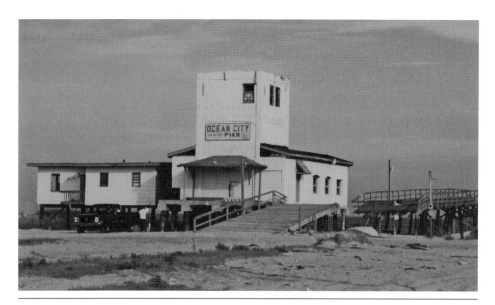

Tower Six, located in what was established as Ocean City, housed a tackle shop and restaurant in the 1950s. After the Ocean City Pier was built in 1959, it expanded to become the pier house. In its heyday, the tower was a bustling hub of activity for the growing African American community. Storms of the 1990s hit the complex hard, closing the operation down. Very little has changed since early talks about demolition and/or renovation of the tower. (Courtesy of David Stallman and *Echoes of Topsail*.)

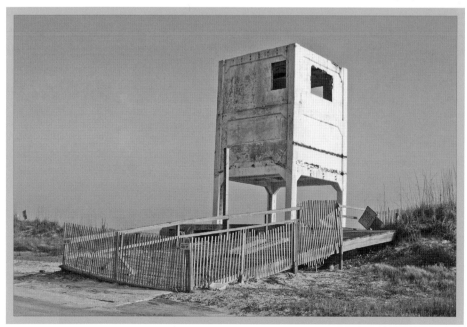

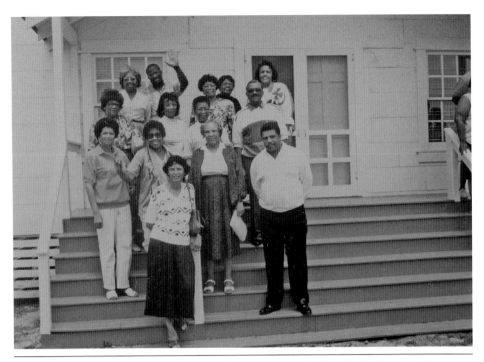

St. Mark's Chapel was built in 1957 on land donated to the Diocese of East Carolina by Ocean City Developers, Inc. The chapel was named for St. Mark's Episcopal Church in Wilmington, where Rev. Edwin E. Kirton served as priest-in-charge until his retirement in 1975. In 1961, Kirton recommended to the bishop that the name be changed to the Wade H. Chestnut Memorial Chapel to honor Chestnut, who was instrumental in founding Ocean City Beach. Shown here is the Fayetteville State Alumnae Association. (Courtesy of Monte Baker.)

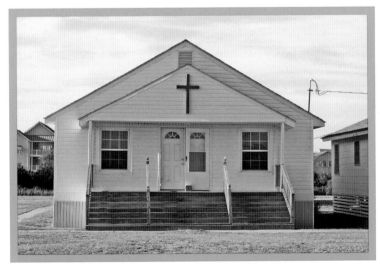

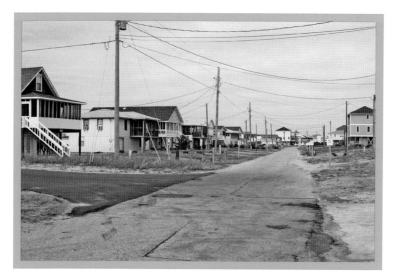

The Ocean City Beach Citizens' Council holds two major gatherings a year, the July picnic and the Octoberfest fish fry. As stated in their 1982 handbook, the little more than 100 families who owned homes in Ocean City were "united in their efforts" to "work and play together for the good of all." In 2009, the community will continue the tradition by celebrating the 60th anniversary of the founding of Ocean City in 1949. (Courtesy of Monte Baker.)

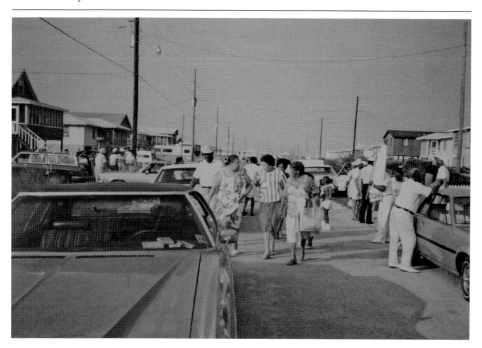

Attorney and businessman Edgar Yow had a radical idea in 1949 to provide the opportunity for African Americans to own beach property. An interracial corporation, Ocean City Developers was formed with the Chestnut brothers—Bertram, Wade, and Robert—auto repair businessmen from Wilmington. Wade H. Chestnut and his wife, Caronell, built the first home. Wilbur Lee Baker, a school principal, owned the 575 Ocean Drive house shown here in 1979. The present-day photograph shows new homes being built in the area. (Courtesy of Monte Baker.)

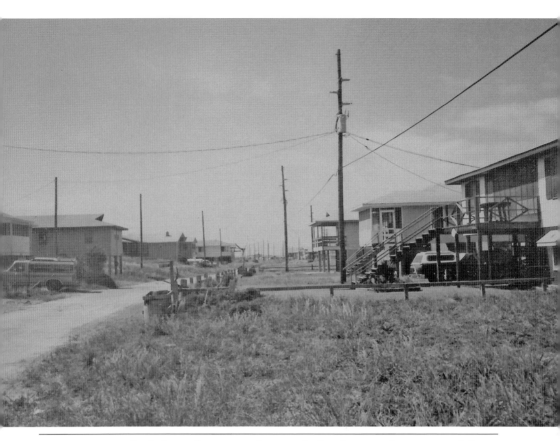

Ocean City was divided into business and residential areas. Houses were required to be built "from the ground up" with no "house trailers or mobile homes" allowed. The first contractor was William Eaton from Fayetteville, who built 30 houses, a motel, church, camp dormitory, and dining hall. This photograph shows Ocean Drive, a residential street with the oceanfront homes on the left. Today only some of those homes have been rebuilt after being hit by storms. (Courtesy of Monte Baker.)

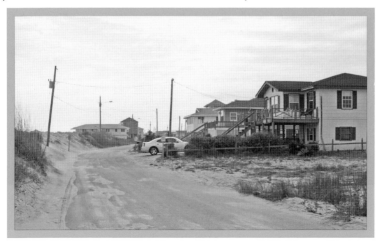

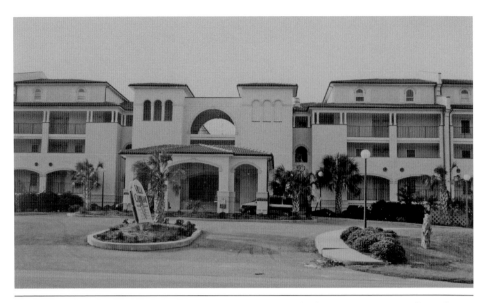

Villa Capriani brings a little bit of the Mediterranean to Topsail with its distinctive architecture and decor. The Villa Capriani resort is located at 790 New River Inlet Road, the sole road to the north end of the island. Also known as State Road 1568, it was rebuilt after Hurricanes Bertha and Fran hit the area in 1996. Tetterton Management Group also took over management of the 116 residential units after the storms and continues in that position today. (Courtesy of Anne and Dick Bishop.)

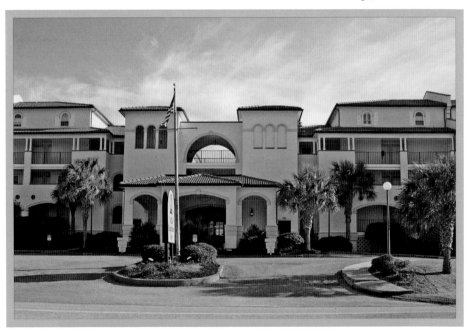

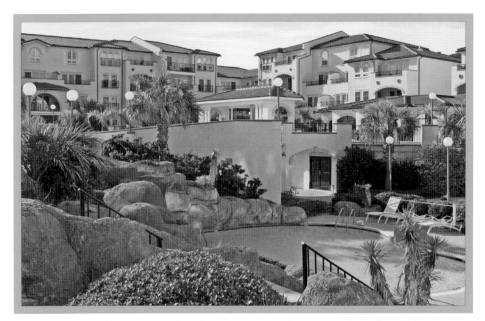

For 30 years, Villa Capriani has been a vacation destination for visitors from all over the country. There is no commercial district in North Topsail Beach, so the nearest restaurants and shopping are across the high-rise bridge in nearby Sneads Ferry. Over the years, there have been on-site restaurants at the resort, including Paliotti's of former Pirate's Den fame. Today Bella Luna Oceanfront Bistro provides fine Italian dining at the Villa. (Courtesy of Anne and Dick Bishop.)

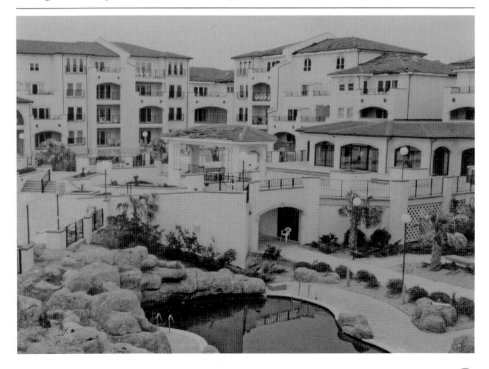

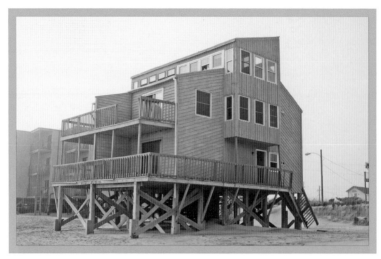

Clouded in controversy, this is one of several homes at the northernmost end of the island now on the ocean side of the dune line that have fallen into extreme disrepair because of storm damage, rising tides, and sea levels. After much legal wrangling, a settlement was reached between the homeowners and North Topsail Beach. The condemned homes are slated for demolition in a matter of weeks from the writing of this book. (Courtesy of Janeise and Sam Collins.)

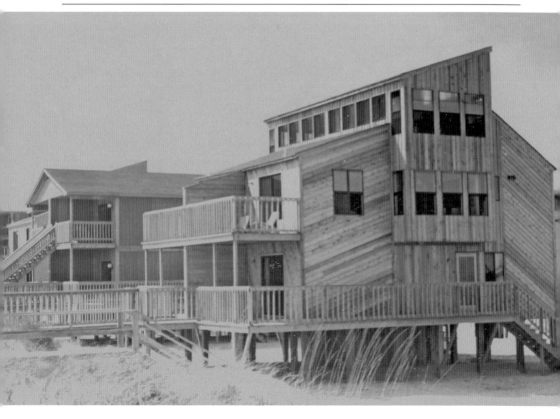

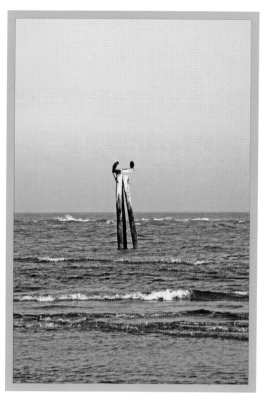

The north end of the island is equally blessed and cursed to be surrounded by three bodies of water—the Atlantic Ocean to the east, the New River Inlet to the north, and the Intracoastal Waterway to the west. Here is realtor Janeise Collins and her dogs at a marker that sat in a wider beach than exists today, evident at high tide when it is surrounded by water. (Courtesy of Janeise and Sam Collins.)

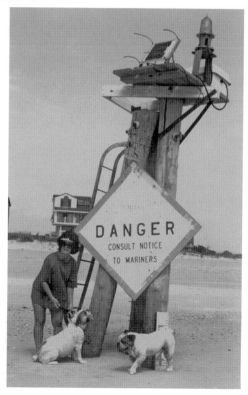

North Topsail Shores was a 1,200-acre resort development community on the north end of the island that included several residential offerings, including the condominiums of Topsail Reef, Topsail Dunes, Shipwatch Villas, and St. Regis Resort. Shown here is an early shot of the northernmost building in the Topsail Reef complex, which looks much the same as it does today. The initial building of eight was completed and occupied in July 1980. (Courtesy of Janeise and Sam Collins.)

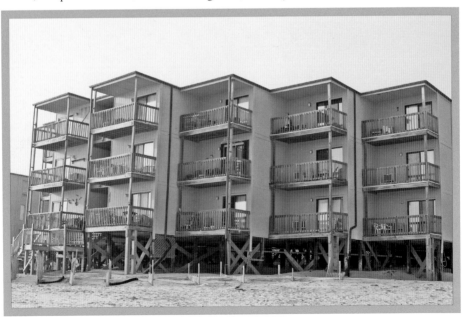

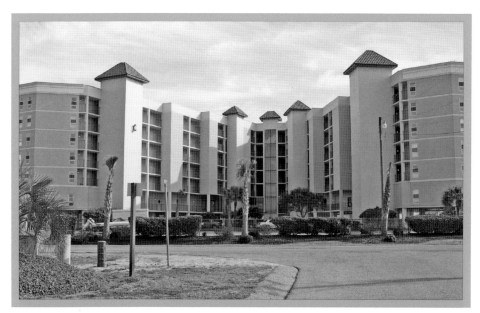

St. Regis Resort and Conference Center is the northernmost resort on the island. Described in early brochures as providing "more of a hotel-like atmosphere with onsite retail services," St. Regis offers one-, two-, and three-bedroom luxury suites in three spectacular buildings. The facility is situated oceanfront across the Intracoastal Waterway from the mainland and Sneads Ferry. The Atlantis Restaurant, formerly Mariner's Way and Quarterdeck Lounge, fills the seventh floor and boasts breathtaking views of the coastline. (Courtesy of St. Regis Resort.)

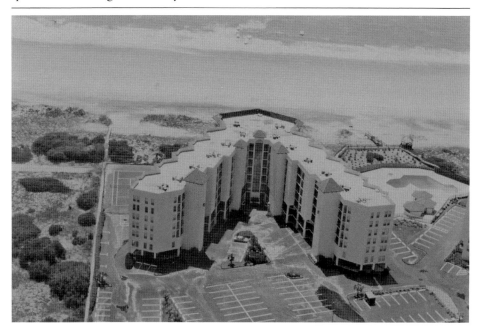

West Onslow Beach Bridge, connecting the north end of the island to Sneads Ferry, was dedicated in August 1969 with much fanfare. State senator Albert J. Ellis was master of ceremonies, and former governor Dan Moore and Gov. Bob Scott were in attendance. The festivities included a motorcade from Jacksonville and a fish fry at Dixon School. This postcard was one in a series of coastal cards created by Helen M. Tatum and Penslo the Pirate of Stump Sound Road, Holly Ridge. (Courtesy of Missiles and More Museum.)

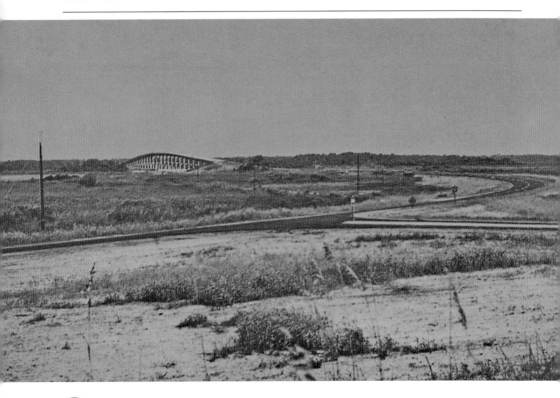

SNEADS FERRY

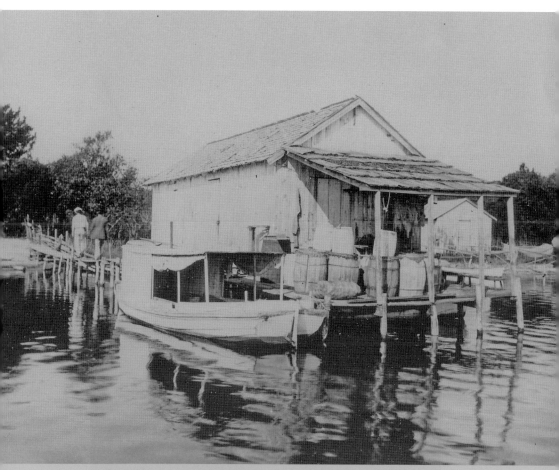

The village of Sneads Ferry was settled around 1775, making it the oldest established community in Onslow County, which itself was established in 1734, making it one of the oldest counties in North Carolina. Sneads Ferry is located on the New River, one of the few rivers in the United States that flows almost due south. (Courtesy of Bernice Guthrie.)

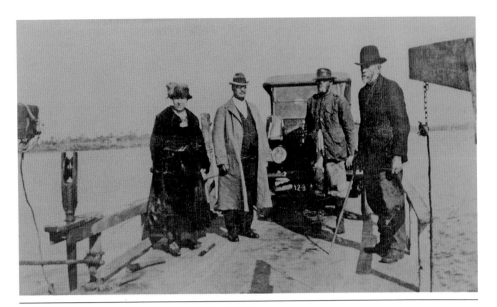

The first license to operate a ferry here across the New River was granted to Edmund Ennett in 1725. Originally known as Lower Ferry, it was renamed Sneads Ferry in 1760 in honor of the new ferry operator, attorney Robert Snead. Snead was convicted of the murder of Revolutionary War hero Col. George W. Mitchell in 1791 but received a full pardon from Gov. Richard Dobbs Spaight. The ferry ran in the area where today Old Ferry Marina Boat Storage and Waterfront Park is located. (Courtesy of Bernice Guthrie.)

For many years, getting from one side of the river to another involved taking a ferry. The ferry became a key element in the Post Road linking Suffolk, Virginia, with Charleston, South Carolina. In the late 1930s, the ferry system was replaced by the first bridge, near the site of the original ferry. This photograph, hand dated 1929 to 1942, shows the first bridge at Sneads Ferry, which was constructed of wood. (Courtesy of Bernice Guthrie.)

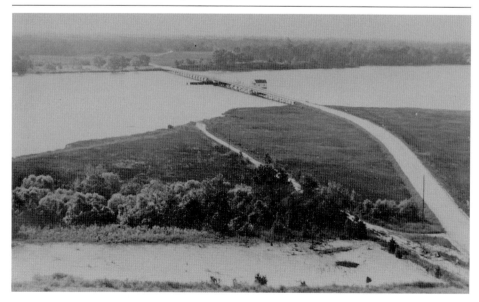

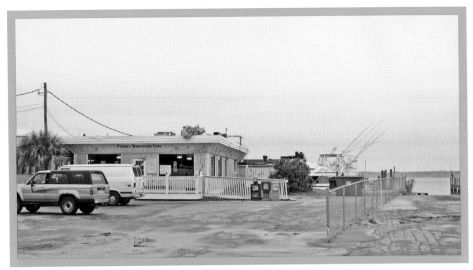

Fulcher's Landing is the oldest settlement in Sneads Ferry, so named after Joe Fulcher started the first fish house and a large contingent of Fulchers moved into the area. Dated October 30, 1912, the photograph lists the owner as Jim Fulcher. Today the Waterfront Café (formerly the Pirate's Cove and Mystic Mermaid) sits in about the area of the Fulcher fish house. Next door is Yopp's Tackle Shop, where the Yopp family's fish house was once located. (Courtesy of Bernice Guthrie.)

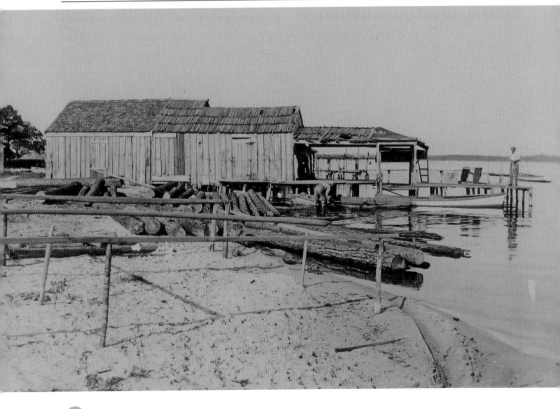

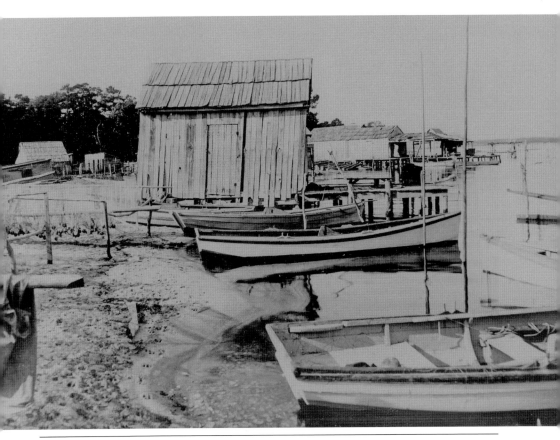

Dated October 30, 1912, this photograph depicts what the area known as Fulcher's Landing looked like as numerous fish houses, stores, and restaurants crowded the waterfront. The notation lists U. G. Canady as the owner, and it is said that this structure was used for storing fishing material. It was located to the right of where the long-standing Green Turtle Restaurant sits today, which was once the Edgewater Restaurant. (Courtesy of Bernice Guthrie.)

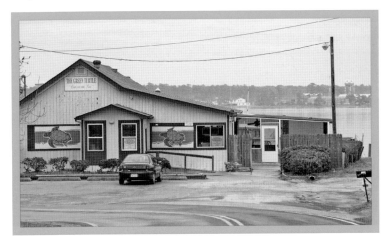

Sneads Ferry is known for its fish houses that sell tens of thousands of pounds of seafood to wholesale markets every year. L. T. Everett and Sons Seafood sits behind Riverview Café on the waterfront in the Fulcher's Landing area. A wholesaler, distributor, and retailer, Everett's has been in business since the early 1940s. Riverview Café, on the wharf overlooking Court House Bay, is a Sneads Ferry tradition. John Terwilliger and family opened it in 1946. Cathy Gandy Medlin and her brother, Jerry Gandy, are shown in this early view of Riverview dated 1954. (Courtesy of Bernice Guthrie.)

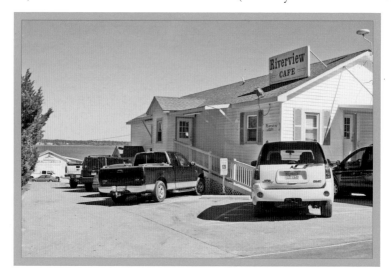

Across the New River from Fulcher's Landing was the village of Marine. Many people assume that it was named Marine because of the proximity of the Camp Lejeune Marine Base. Instead, it was named for the Marine family, who migrated to the area and stayed for generations. Marine was a thriving community, as shown in this early photograph. Even today, the Marine family gathers annually for a reunion. The current photograph shows the view across Courthouse Bay. (Courtesy of Bernice Guthrie.)

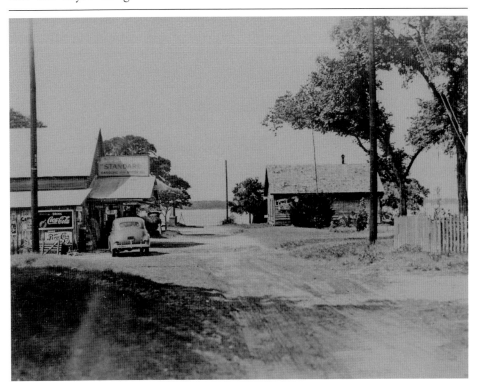

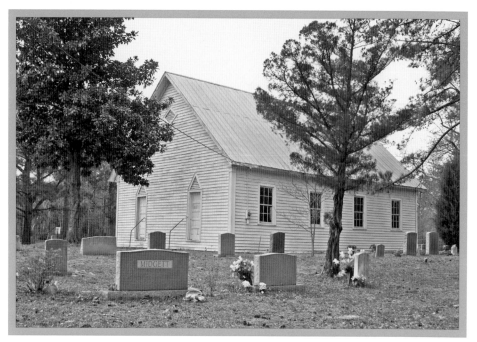

Yopps Meeting House, located at 2363 Highway 172, was built in the early 1890s, replacing what is believed to be the original log structure built in 1832 that burned. In 1835, it was known as Yopp's Primitive Baptist Church with 33 charter members. It was built in the Primitive Baptist fashion with separate doors for men and women. The cemetery that wraps around the meetinghouse contains grave markers dating back to the 1700s. (Courtesy of Bernice Guthrie.)

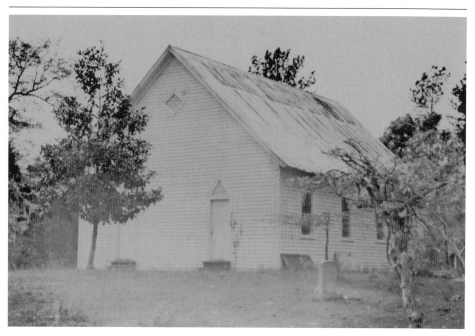

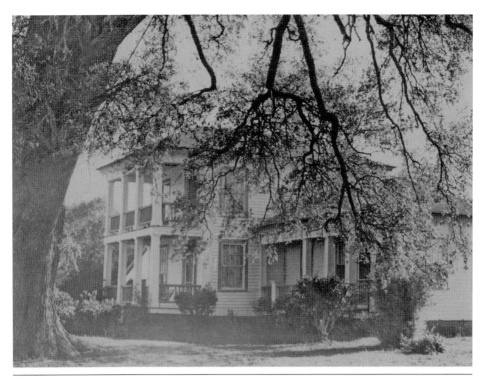

Often called the Hill House by locals, this beautiful home nestled in the woods is purportedly the second oldest home in Onslow County. Built by Dr. George Ennett around 1860, the one-story section was used as an office. The two-story structure was added just before 1868. It was sold to Capt. John Hill in March 1874. The current owners, Debbie Ann and Kevin Hicks, coach and teach at Dixon Middle School. (Courtesy of Bernice Guthrie.)

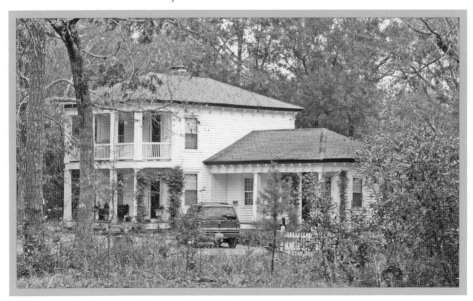

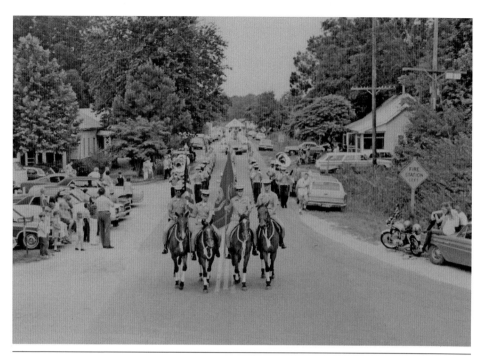

Sneads Ferry has hosted the Sneads Ferry Shrimp Festival for nearly 40 years. Shown here is an impressive community parade complete with floats and the Queen's Ball winners, along with the marine band and community supporters. The festival features art and crafts, a street dance, fireworks, and shrimp contests. Thurston's Gallery and Jingle Bells Shopping Village are popular destinations for shopping. Sherry Thurston is perhaps best known for her Sneads Ferry sneakers art. (Courtesy of Bernice Guthrie.)

CHAPTER 5

HAMPSTEAD

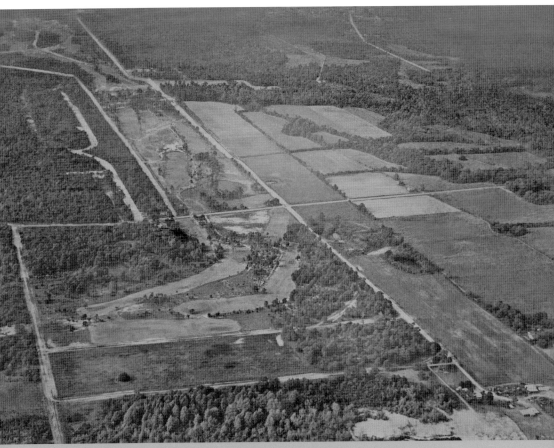

Hampstead got its name from the railroad that once ran along the coast over a century ago. But popular legend has it that Hampstead got its name from George Washington in the late 1780s, when he was visiting the area and wanted to eat Topsail Sound mullet. But the mullet were not running so he had to eat "ham instead." The aerial image shows farmland where Topsail Greens is today. (Courtesy of the Graham Cole family.)

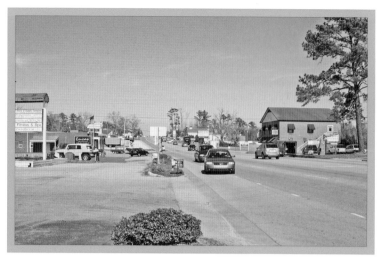

Referred to as the "Seafood Capital of the Carolinas," Hampstead has been called home by two seafood distributors for decades. J. H. Lea and Sons opened its doors in 1918. Atlantic Seafood Company was established in 1964. In late 2008, Atlantic bought J. H. Lea, solidifying its position as one of the largest suppliers in the Southeast. Also notable in the older photograph is the Venus Flytrap store on the left, now gone, and in the now photograph, the brick Weir building, which houses Everyday Dreamers Real Estate. (Courtesy of Hampstead Barber and Beauty Shop.)

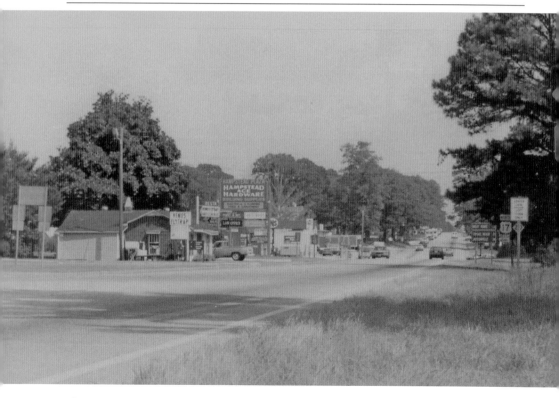

RBC Centura Bank is located at the traffic light at 14615 U.S. Highway 17 and Highway 210. It sits across Highway 210 from the BP station and across U.S. Highway 17 from CVS Pharmacy. In the 1940s, Alex Futch, shown here, and his wife, Eddy Mae, brought in a cable or trolley car and opened a popular restaurant on that same corner. Often referred to as Futch's Café or Futch's Restaurant, the charming place was only open a few years. (Courtesy of Hampstead Barber and Beauty Shop.)

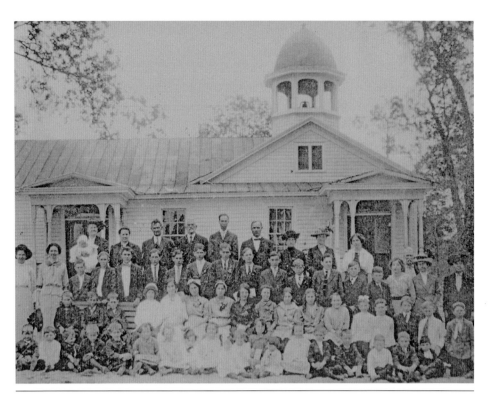

The early 1900s Hampstead School was located on what is now a dirt road, behind and to the left of the Doublewide Skate and Surf Shop off Highway 17, where a couple of residences sit today. Some say the road follows the path of a discontinued rail line. Others say the rail ran farther back. Opal Gornto came from Sneads Ferry to teach and married Winfred Batts. Their daughter Jacklyn married Jesse Lea and had two sons, Kenny and Jesse Lea Jr. (Courtesy of Hampstead Barber and Beauty Shop.)

In the late 1970s, Mark Long and his wife, Jan Lewis, of Poplar Grove Plantation bought the residence (shown below) and opened the Christmas House, which expanded to a Christmas Village composed mostly of old buildings that were brought in from all over during the 1980s. The Christmas House burned down, but the shopping center continued, first with Grant Seagraves as owner and then Fitz Hugh Lee. The Lee family trust continues to own what is now named Cedar on the Green Shopping Center. (Courtesy of Hampstead Barber and Beauty Shop.)

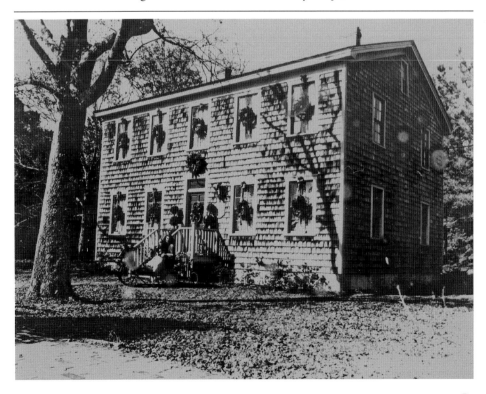

James "Jim" Howard ran a general store that sold everything from nails in kegs to food and gasoline. Standing in front of what was referred to as Uncle Howard's Store are, from left to right, ? Coston, Henry Battson, Paul Simmons, L. W. "Straghty" Howard, and Howard Simmons. Today the Coastal Cash Exchange sits on the site at the corner of U.S. Highway 17 and Peanut Road. Lucas and Associates Realtors are located next door in the old post office building. (Courtesy of Hampstead Barber and Beauty Shop.)

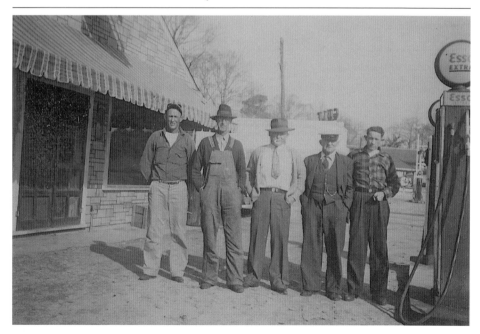

The Hampstead Grocery, or as many called it, Mr. Piver's Grocery (note the name on the sign), was another general store located at Peanut Road and U.S. Highway 17 right next to the former J. H. Lea and Sons seafood business, now Atlantic Seafood. Bellamy Transmissions and Brake Repair, in a different building, sit on the site today. Some say the old concrete pad (see photograph) is still there and that the blocks "might" be leftover from the Piver days. (Courtesy of Hampstead Barber and Beauty Shop.)

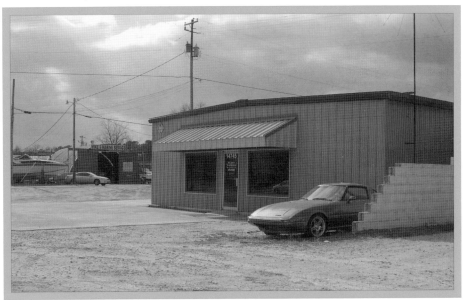

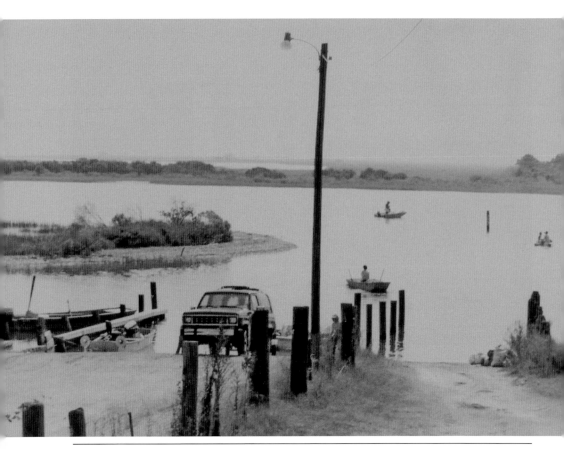

Hampstead Marina, formerly known as Honeycutt Landing, is located off of U.S. Highway 17 at the end of Factory Road, a reference to the old salt factory that was in the area. Owners Joseph Newman Honeycutt and Stella Murray Honeycutt sold the popular boat launch to their daughter Joyce H. Wooten and her husband, H. Allen Wooten, in 2002. (Courtesy of Hampstead Barber and Beauty Shop.)

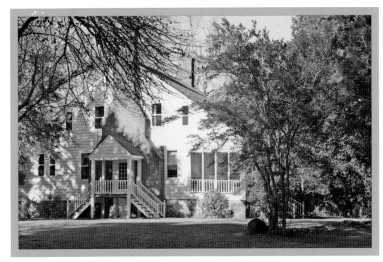

The Sloop Point Plantation house has been authenticated as the oldest surviving structure in North Carolina, recorded in the National Register of Historic Places in 1972. It was built in 1725 by Elizabeth Lillington Swann Ashe and John Baptista Ashe, the father of Samuel Ashe (who was speaker of the first North Carolina Senate, judge of North Carolina's first Superior Court, and North Carolina's ninth elected governor). Gov. Samuel Ashe was also instrumental in the founding of the University of North Carolina. (Courtesy of Hampstead Barber and Beauty Shop.)

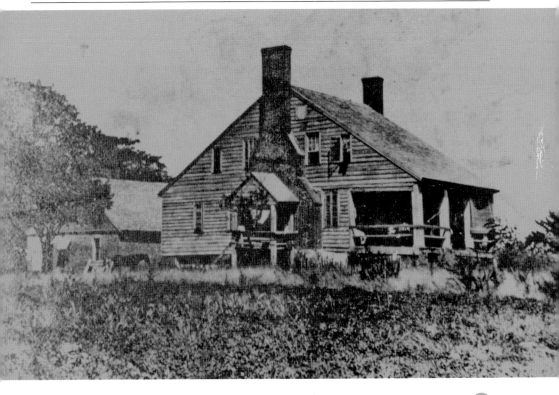

www.arcadiapublishing.com

MAP SEARCH

Discover books about the town where you grew up, the cities where your friends and families live, the town where your parents met, or even that retirement spot you've been dreaming about. Our Web site provides history lovers with exclusive deals, advanced notification about new titles, e-mail alerts of author events, and much more.

MADE IN THE
USA

Arcadia Publishing, the leading local history publisher in the United States, is committed to making history accessible and meaningful through publishing books that celebrate and preserve the heritage of America's people and places. Consistent with our mission to preserve history on a local level, this book was printed in South Carolina on American-made paper and manufactured entirely in the United States.

This book carries the accredited Forest Stewardship Council (FSC) label and is printed on 100 percent FSC-certified paper. Products carrying the FSC label are independently certified to assure consumers that they come from forests that are managed to meet the social, economic, and ecological needs of present and future generations.

FSC
Mixed Sources
Product group from well-managed forests and other controlled sources

Cert no. SW-COC-001530
www.fsc.org
© 1996 Forest Stewardship Council

Find Your Place in History.